W9-BGZ-670

fantastic
plastic cameras

fantastic
plastic cameras

Tips and Tricks for 40 Toy Cameras

By Kevin Meredith

CHRONICLE BOOKS

SAN FRANCISCO

First published in the United States in 2011
by Chronicle Books LLC.

Library of Congress Cataloging-in-Publication
Data available.

ISBN: 978-0-8118-7753-4

Cover design: Emily Dubin
Art Director: Emily Portnoi
Design concept: Emily Portnoi
Design and layout: Lisa Båtsvik-Miller
Editor: Lindy Dunlop
Page 2 image by: Jason Swain, Lensbaby 2.0
with Macro, deliberate overexposure

Typeset in Triplex and Mr Eaves Modern
Manufactured in China.

Published and distributed outside of North America
by RotoVision SA.
Route Suisse 9
CH-1295 Mies
Switzerland

10 9 8 7 6 5 4 3 2 1

Chronicle Books LLC
680 Second Street
San Francisco, CA 94107

www.chroniclebooks.com

The Publisher would like to thank all the photographers
who so generously contributed images to this book,
including Rachael Ashe, Elena García Ibáñez, Adam
Remsen, and Daniel Rodriguez whose images we were
unfortunately not able to include

CONTENTS

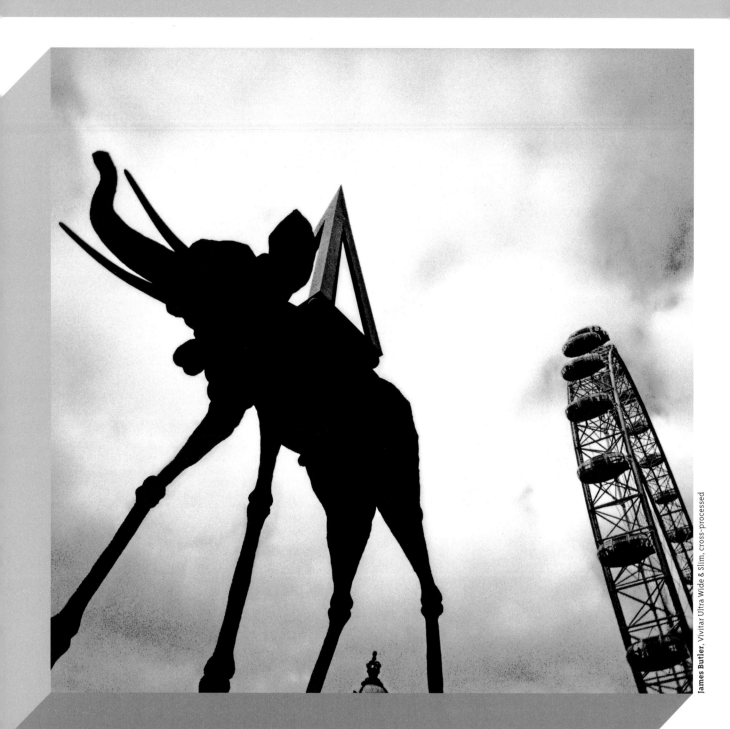

WHAT IS A TOY CAMERA?

Maybe a better question to ask is "What is a serious camera?" The answer to that question is simpler. A serious camera is one that has been designed to capture a scene with as much accuracy as possible. The resulting images, while technically perfect, can seem a bit lifeless to some people. Toy cameras are ideal for photographers who don't want to capture a polished version of the world. As most toy cameras are plastic, the terms are often used interchangeably, and it is largely down to this cheaper plastic design that they have such characteristic quirks, which may not be intentional. These make the images they produce less technically perfect, most typically because of overlapping frames, light leaks, or lens distortions, but the toy camera distinction is not always about the quirks. Some rely on a novelty factor such as adding color to their flash or capturing multiple frames.

You could argue that a toy camera is a toy camera because of its market value, but that is not my view. Some people wouldn't consider the Lomo LC-A a toy camera because it has a high price tag compared with other toy cameras, but when compared with "prosumer" digital SLRs, their price is not that high. You can't really put an upper limit on the cost of toy cameras: as a specific camera peaks in popularity and its selling price goes up, would it stop being a toy?

Using toy cameras is about letting go of a certain level of control. Most are quite basic, lacking such things as a light meter, a means of exposure control, or a changeable focus. For me, if you shoot with toy cameras you are making a statement that photography doesn't have to take itself too seriously.

Ultimately, what you consider a toy camera is down to you. Whether you are using your high-tech DSLR with a cheap plastic add-on as a toy camera or you have fallen in love with some plastic fantastic you found at a thrift store, it doesn't matter. It is about toying with your creativity and having fun doing it.

CAPTIONS:

For each image we have credited the photographer. Where a variant model of the camera discussed was used, on its own or in addition to it, that camera model is also given, along with any additional photographic or processing techniques that were used. If no extra details are given, the photo is as the camera has captured it.

HOLGA CFN 120

MEDIUM: 120 film

ISO RANGE: All ratings available

LENS: fixed, plastic, 60mm

FOCUS: 1m (3¼ft) to infinity

FLASH: built-in Colorsplash

APERTURE: f/11 or f/8

SHUTTER SPEED: 1/125 sec or B (bulb)

SIMILAR CAMERAS: Diana F⁺ (p 42) / No. 2 Portrait Brownie (p 62)

VARIANT MODELS: Holga 120S / Holga TLR / Holga 120 3D Stereo Camera / Holga 120PC / Holga-120WPC

Well known for light leaks, Holga photos are easily identified by their characteristic blurred edges and vignetting.

The Holga is one of the more popular toy cameras, but this is certainly not for its looks! Holgas are quite large: they are medium-format cameras and take 120 film, which is more often used by professional photographers than by toy-camera hobbyists. The Holga offers by far the cheapest way to get into medium-format photography as most medium-format cameras are aimed at the high-end professional market. There is one drawback, though—you get only 12 or 16 shots from one roll of film, so film and developing costs work out a lot more expensive per shot than with 35mm film. You can choose to shoot 16 exposures per 120 roll in 6 × 4.5cm format, or go for 12 exposures in 6 × 6cm format.

The "Holga light leak" occurs because the film door doesn't always shut tightly against the body of the camera, allowing light to reach parts of the film. While many Holga users like the effect this produces, it is often undesirable, and most users seal up their camera with duct tape every time they load film.

With many film cameras, winding the film on reloads the shutter but with the Holga, the shutter is independent of film winding. You can choose not to wind on in order to take a double exposure, or you can wind on part of the way before taking the next shot to produce a set of overlapping images. This makes the Holga an ideal choice if you are into experimentation.

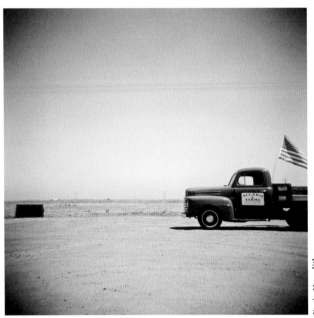

Kevin Meredith

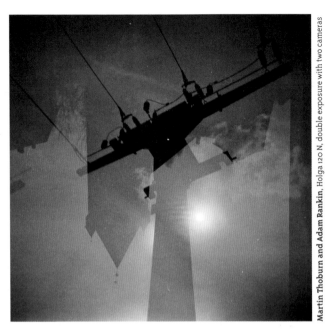

Martin Thoburn and Adam Rankin, Holga 120 N, double exposure with two cameras

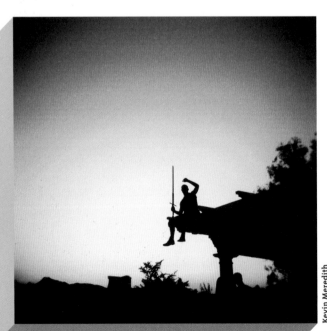

Kevin Meredith

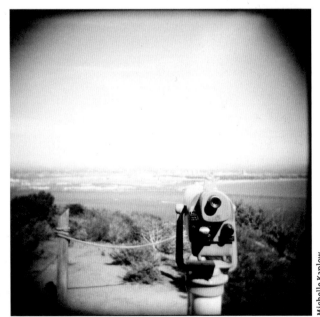

Michelle Kaplow

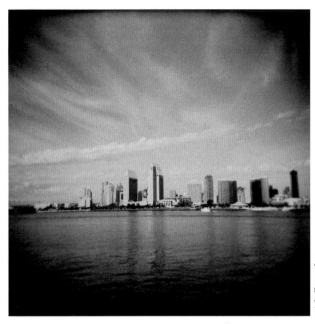

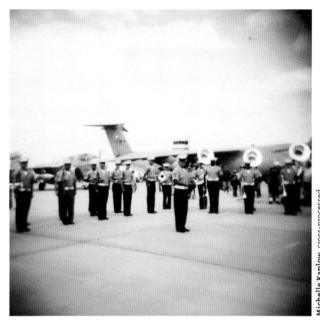

Michelle Kaplow

Michelle Kaplow, cross-processed

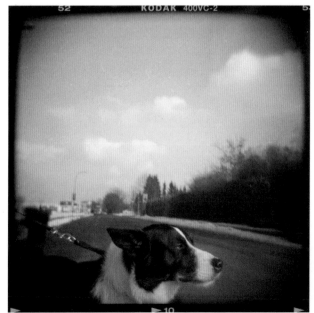

Lutz Bornemann

Lutz Bornemann

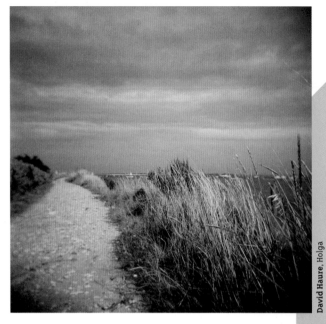

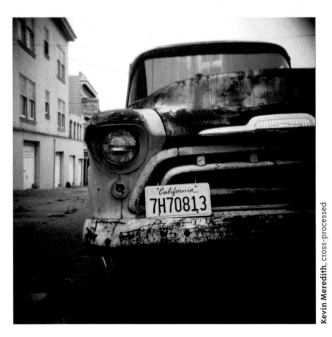

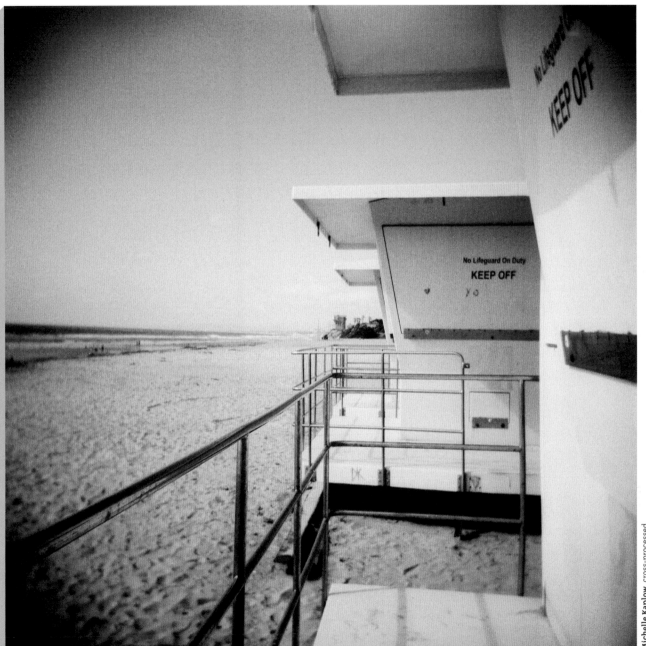

ACTIONSAMPLER CLEAR

MEDIUM: 35mm film

ISO RANGE: All ratings available

LENSES: four, fixed, 26mm

FOCUS: 1.2m (4ft) to infinity

FLASH: —

APERTURE: fixed, not specified

SHUTTER SPEED: 1/100 sec

SIMILAR CAMERAS: Robot 3 (p 138) / Aryca (p 96)

VARIANT MODELS: ActionSampler Flash (p 74)

ActionSampler cameras are known for their distinctive motion-blurring.

With see-through casing and multicolored internal gears, the ActionSampler Clear is one of the most toylike toy cameras available. In the late 1990s it was known simply as the ActionSampler, but as there are now a number of different ActionSampler cameras available, it has been rebranded as the ActionSampler Clear. It takes a series of four pictures every 0.22 seconds over a period of 0.66 seconds and lays the four pictures out on the one negative in a 2 × 2 grid.

The ActionSampler's individual shutters fire at a slow shutter speed—1/100 sec. Because of this, some of the individual shots will be motion-blurred if you *are* moving the camera, but you can use this to creative effect by moving the camera during exposures. This will give you a mix of motion-blurred and sharp frames.

Because of its fixed aperture, this camera is only good with high ISO films or in good light.

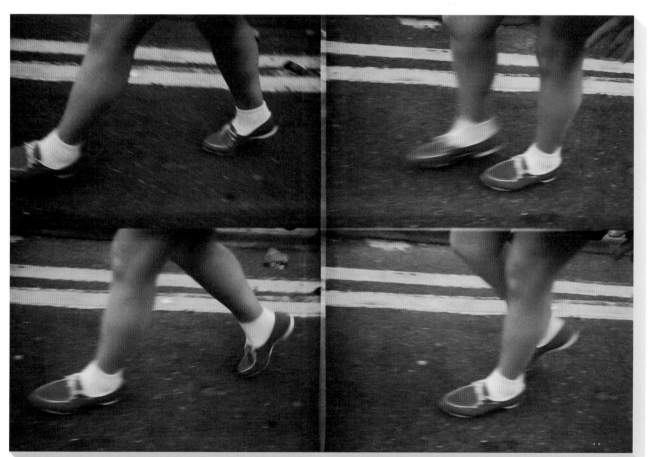

Kevin Meredith

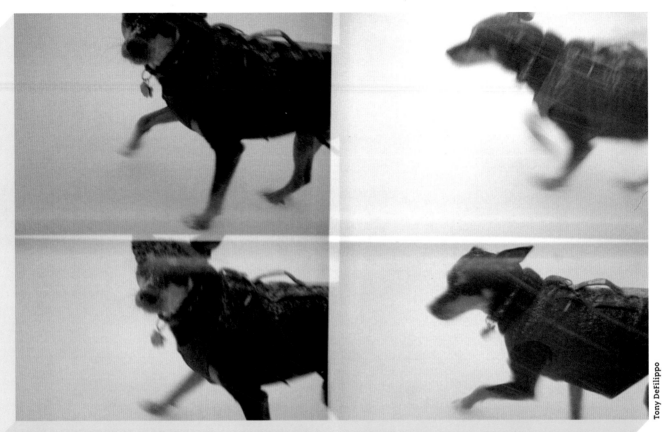

Tony DeFilippo

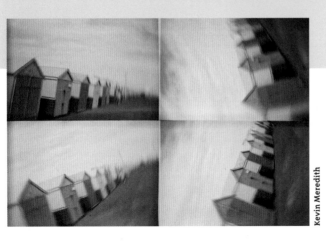

Kevin Meredith

James Butler, ActionSampler Clear and Vivitar Ultra Wide & Slim, double exposure, cross-processed

Mantas Pelakauskas

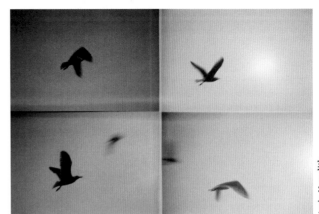

Kevin Meredith

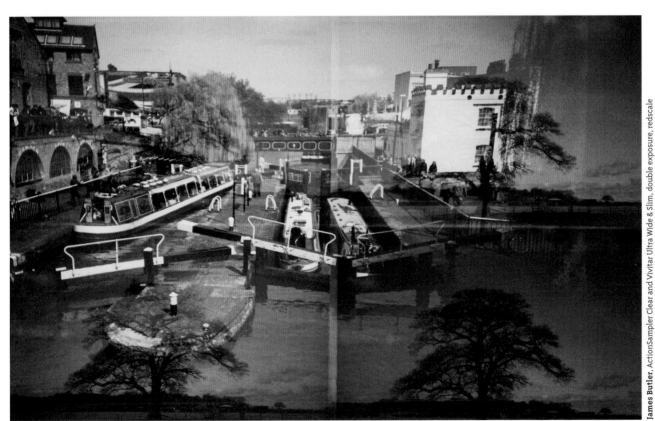

James Butler, ActionSampler Clear and Vivitar Ultra Wide & Slim, double exposure, redscale

LOMO FISHEYE 2

MEDIUM: 35mm film

ISO RANGE: All ratings available

LENS: fish-eye with 180°
field of view

FOCUS: 30cm (12in) to infinity

FLASH: built-in and hot shoe
to take flash

APERTURE: not specified

SHUTTER SPEED: 1/60 sec or B (bulb)

SIMILAR CAMERAS: Lomo LC-A+
(p 22) with wide-angle lens

VARIANT MODELS: Lomo Fisheye /
Lomo Fisheye Submarine

An ultra-wide lens with a 180° field of view gives images produced by the Lomo Fisheye 2 a distinctive circular format.

The Fisheye 2 comes with a little view-finder that can be slipped onto the camera's flash hot shoe, but you don't really need it as, generally, anything in front of the lens will be in the photo. As with a lot of viewfinders, it becomes less accurate the closer you are to your subject.

Much fun can be had taking close-up portraits of friends, the result being very distorted features. The Fisheye 2 is also great for self-portraits, even while you're cycling or rock climbing. You can just hold the camera at arm's length, facing in. The wide field of view guarantees you'll get yourself in the picture.

It's not just the wide field of view you can toy with. This camera also has a bulb setting for shooting long exposures in low light, and it has a feature that allows you to double expose at the flick of a switch.

This is the second version of the Lomo Fisheye. The original, which is still available, and cheaper, doesn't allow you to double expose, nor does it have a flash hot shoe, but it does have a built-in flash. The lack of a hot shoe means that you can't use the slide-on viewfinder from the Fisheye 2, and, while the Fisheye does have a built-in viewfinder, its view is partially obscured by the main lens.

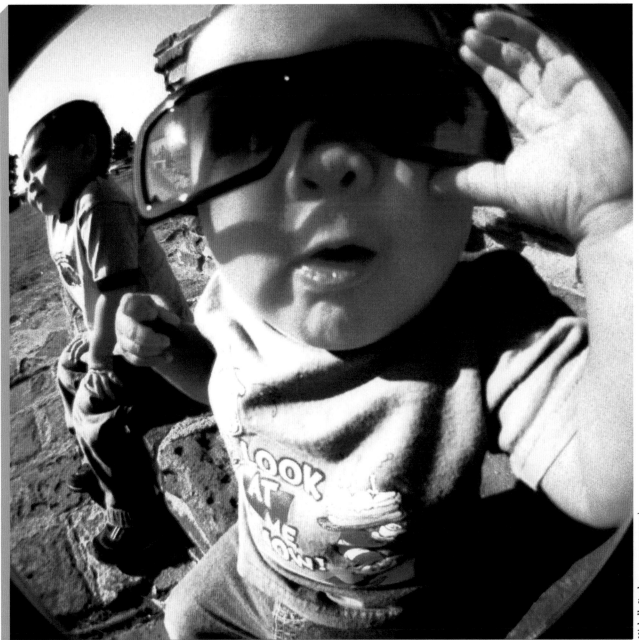

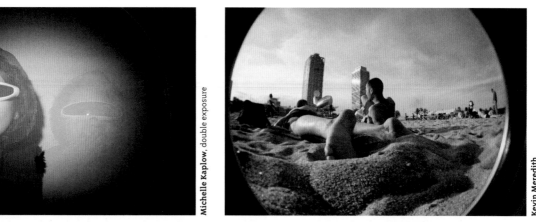

Michelle Kaplow, double exposure

Kevin Meredith

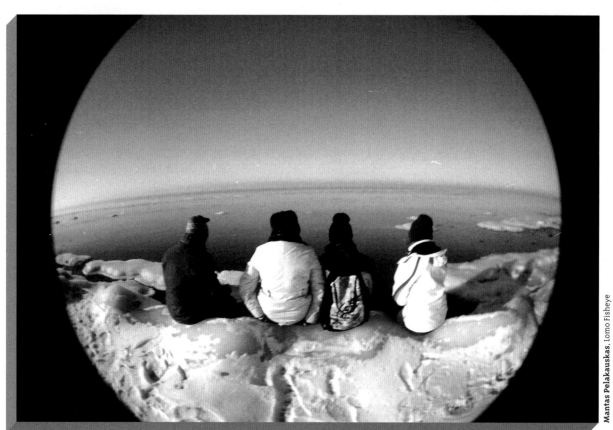

Mantas Pelakauskas, Lomo Fisheye

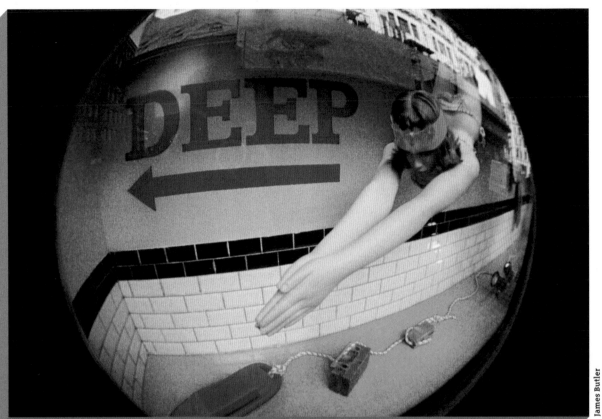

James Butler

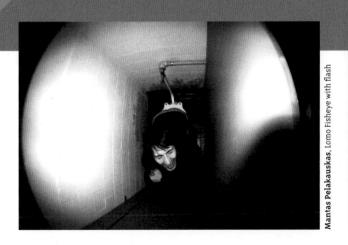

Mantas Pelakauskas, Lomo Fisheye with flash

Michelle Kaplow, green flash

LOMO LC-A & LOMO LC-A+

MEDIUM: 35mm film

ISO RANGE: manual, 25 to 400 (LC-A), 100 to 1600 (LC-A+)

LENS: fixed, glass, 32mm, 1:2.8

FOCUS: 80cm (2½ft), 1.5m (5ft), 3m (10ft), or infinity

FLASH: hot shoe to take flash

APERTURE: f/2.8 to f/16

SHUTTER SPEED: 1/500 sec to 2 minutes

SIMILAR CAMERAS: Cosina CX-1 / Cosina CX-2 / Olympus XA-2 / Zenith LC-A / Zenit LC-A

VARIANT MODELS: —

Shots taken with the Lomo LC-A are easy to spot because of their very strong lens vignetting.

The Lomo LC-A helped to start the toy camera craze. Whether it is a toy camera is debatable, but its importance to the toy camera movement is such that it has to be included in this book.

All you have to do before you take a picture is judge how far away your subject is from the camera: 80cm (2½ft), 1.5m (5ft), 3m (10ft), or infinity. The LC-A does allow you to control aperture, but this feature is seldom used, so aperture control was removed from the newer LC-A+.

The LC-A's characteristic vignetting is caused by an imperfection in its lens— it allows more light to come through the middle than the edges. This effect can be exaggerated by cross-processing, which increases the overall contrast and saturation in an image and is a very popular technique with LC-A users.

The LC-A's greatest strength is the way its shutter speed works: under dark conditions, the shutter will stay open for as long as required. This makes it a great compact camera for low-light photography, an area in which a lot of modern digital compacts can struggle. The way the LCA's light metering works also sets it apart from other cameras. Normally the shutter speed is set once you press the shutter button; on the LC-A, the aperture is set when the shutter button is pressed, then the shutter opens to allow the exposure to start. If the light gets brighter or darker during an exposure, the camera will compensate by increasing or decreasing the length of time the shutter stays open.

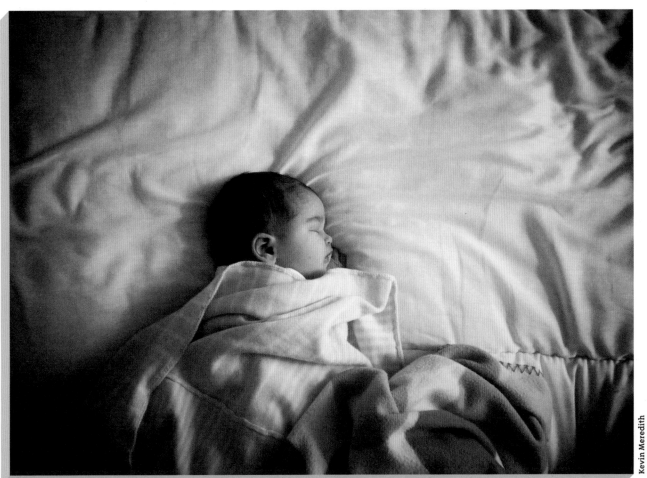

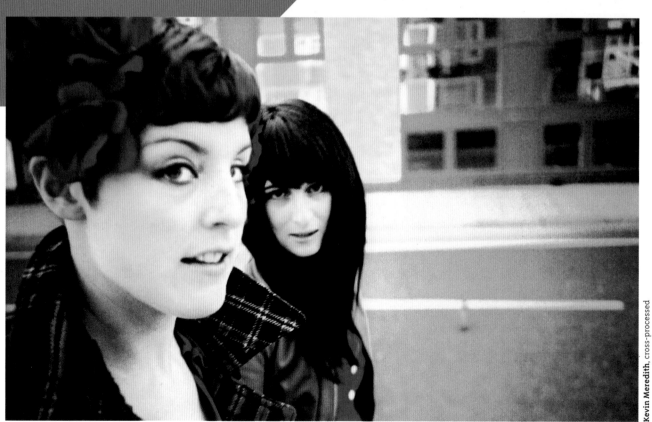

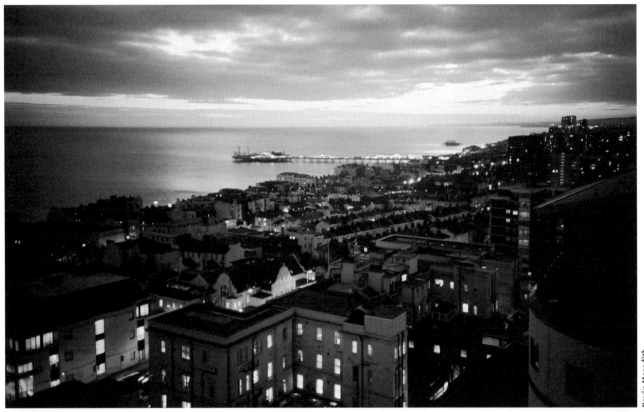

Kevin Meredith

Kevin Meredith, cross-processed

Mantas Pelakauskas, double exposure

POP⁹

MEDIUM: 35mm film

ISO RANGE: All ratings available

LENSES: nine, fixed, 24mm

FOCUS: 80cm (2½ft) to infinity

FLASH: built-in

APERTURE: fixed, f/11

SHUTTER SPEED: fixed, 1/100 sec

SIMILAR CAMERAS: ActionSampler Clear (p 14) / Aryca (p 96) / Oktomat (p 114) / Kalimar Action Shot 16 (p 146)

VARIANT MODELS: —

The pop⁹ produces an Andy Warhol—style composition in a 3 × 3 grid.

With its nine lenses, the pop⁹ looks like an action-sampling camera, but it doesn't record action, as all its exposures are taken at the same time. You will often read that the pop⁹ gives you nine identical images. This is not strictly true. Each image is ever-so-slightly different. This difference becomes more obvious the closer the subject is to the lens, and it becomes very apparent when the images are animated. The pop⁹ is super small by toy camera standards. One of the smallest 35mm cameras in this book, you'll find it will slip into the tightest of jeans pockets.

The pop⁹ is a great camera for bright sunny days and, thanks to the inclusion of a built-in flash, it also makes a great party camera. And you can cut up the prints to give the results to your friends— the tiny images make great keepsakes.

If you want your pictures to stand out from the crowd, you can modify your pop⁹ by removing the little plastic dividing walls between the internal frames. This will give you images that overlap. By selectively covering and uncovering different lenses, you can create stunning effects.

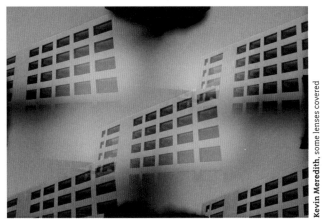

Kevin Meredith, some lenses covered

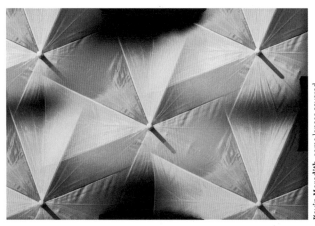

Kevin Meredith, some lenses covered

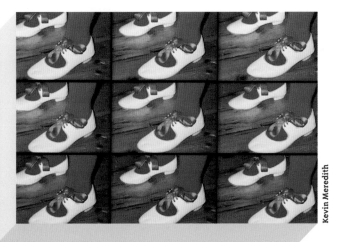

Kevin Meredith

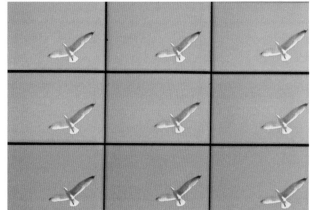

Kevin Meredith

TIME CAMERA

MEDIUM: 35mm film

ISO RANGE: All ratings available

LENS: fixed, plastic, 50mm

FOCUS: 1.8m (6ft) to infinity

FLASH: hot shoe to take flash

APERTURE: f/6, f/8, f/11, or f/16

SHUTTER SPEED: fixed, 1/125 sec

SIMILAR CAMERAS: Lavec LT-002

VARIANT MODELS: —

The Time camera has a 50mm lens that, being quite rare for toy cameras, gives its images a more "real-life" perspective than most.

The Time camera imitates the look of an SLR but lacks the interchangeable lenses and shutter-speed control. It was a free gift to *Time* magazine subscribers in the 1980s. The idea must have been that anyone who was a *Time* subscriber would be into photojournalism, so would appreciate an SLR look-alike. At the time this camera was produced, fixed, 50mm lenses were considered the SLR standard.

The camera has four aperture settings, ranging from f/6 to f/16, and you can use a cable release with it.

The Time camera was made by Taiwanese manufacturer Lavec, who also made the similar Lavec LT-002. There were variant giveaways made for other companies, associated with all sorts of products and services, around the same time.

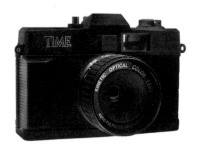

Kevin Meredith

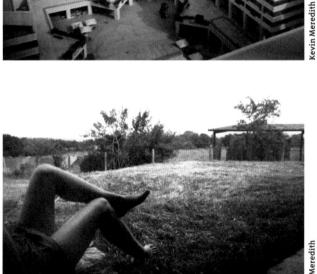

Kevin Meredith

Jennifer Miller

Kevin Meredith

Christopher Evans, negative scanned in color

GAME BOY CAMERA

MEDIUM: digital, built-in

ISO RANGE: —

LENS: not specified

FOCUS: not specified

FLASH: —

APERTURE: fixed, not specified

SHUTTER SPEED: fixed, not specified

SIMILAR CAMERAS: Casio WQV-1CR wristwatch camera

VARIANT MODELS: —

Game Boy images are instantly recognizable for their low resolution and lack of color.

You can't get more toy than the Game Boy camera, which was designed as an add-on for the Nintendo Game Boy. A ball camera that slides into the cartridge slot, it can be twisted to either face you or so you can see what you are going to shoot on the Game Boy's screen.

There is no mistaking an image shot on a Game Boy camera, as each image is made up of only 14,000 pixels—images produced by today's digital cameras are made up of tens of millions. Not only are Game Boy images limited in resolution, they also have a limited depth of color, being made up of only four shades of gray. Other shades are simulated by a pattern effect so that, from a distance, images appear to have a larger tonal range.

Another limitation is that the Game Boy camera can only store 30 images, and getting the images off the camera can be a little tricky. You can get a Game Boy printer, which allows you to print small images onto thermal paper. While the Game Boy paper is no longer available, you can cut thermal paper to size. If you want to preserve your images in all their pixelated glory, you will have to transfer them onto a computer. Again, this can be a little tricky, but there are two options: a USB Game Boy cartridge reader, which works with Macs and PCs, or the cheaper cable that connects the Game Boy's link port to a computer's serial port, but this only works with Windows 98 and a PC *with* a serial port. Getting images off the Game Boy is not for the technically inept!

RGB adjusted for anaglyph

Kevin Meredith: 1–4, 6–8, 11, 16–17, 19–22; Edd Hannay: 9, 10, 12–13, 15, 18; Jim Nowlin: 5, 14, two images layered,

SPINNER 360°

MEDIUM: 35mm film

ISO RANGE: All ratings available

LENS: fixed, 25mm

FOCUS: fixed, 1m (3¼ft) to infinity

FLASH: —

APERTURE: f/8 or f/16

SHUTTER SPEED: —

SIMILAR CAMERAS: Ultronic Panoramic (p 54) / Ansco PIX Panorama / Horizon

VARIANT MODELS: —

The Spinner 360°, as its name implies, captures a full 360° view, with a distinctive wavelike "horizon."

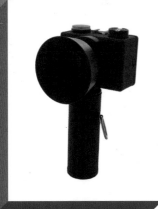

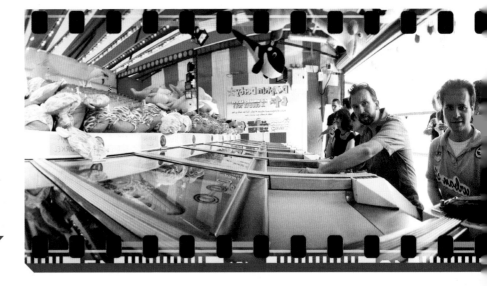

The camera has a large handle attached to its base, which gives it the look of a retro movie camera. To take a picture, you hold the handle and pull a string. When the string is pulled and released, the camera spins on the handle and captures the view as it goes. The clever part is that, as it spins, it pulls the film through itself. Apart from the pull-string, the only control is the aperture switch, which has cloudy, sunlight, and rewind settings.

If the string is pulled all the way out, the camera will spin a full 360° and sometimes a little more. If you don't want to capture 360°, pull the string out just part of the way.

A full panorama will take up six exposures on a roll of 35mm film, so you only get six or seven panoramas from a 36-exposure film. The Spinner exposes the entire film, including the sprocket holes, and, as images cover

six to seven frames when developed, a photo lab might not know what to do with it so you're best off scanning the negative yourself.

The camera feels sturdy as it is made from quite thick, bobbled plastic, and it has a nice weight, which is lacking in some other plastic cameras.

Kevin Meredith

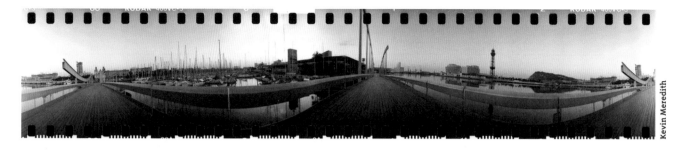

Kevin Meredith

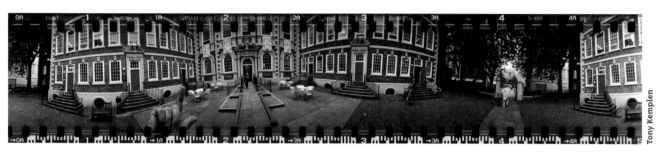

Tony Kemplen

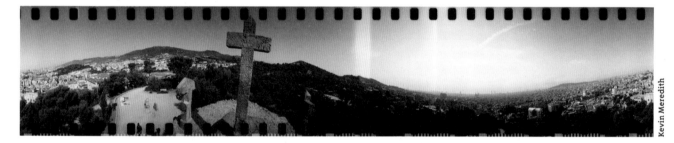

Kevin Meredith

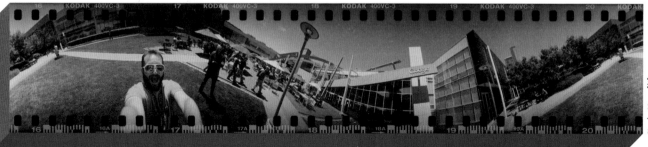

Kevin Meredith

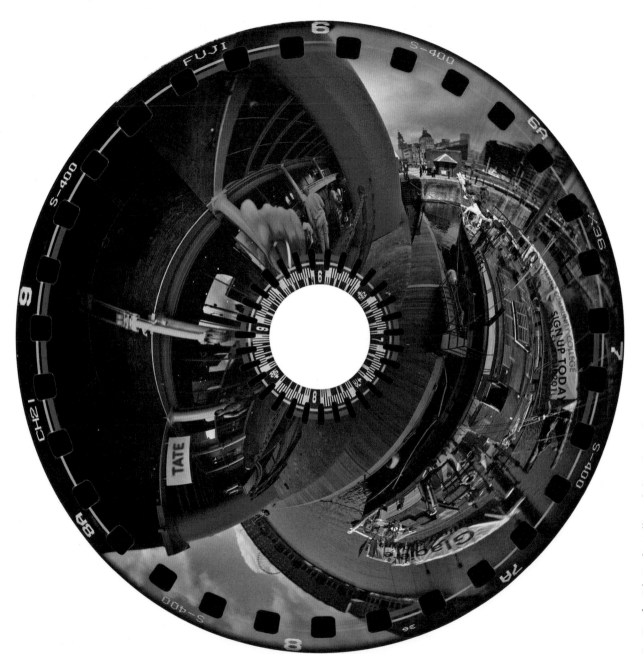

Tony Kemplen. Polar Coordinates filter applied in post-processing

SUPERSAMPLER

MEDIUM: 35mm film

ISO RANGE: All ratings available

LENSES: four, fixed, plastic, 24mm

FOCUS: fixed, 30cm (12in) to infinity

FLASH: —

APERTURE: fixed, not specified

SHUTTER SPEED: fixed, not specified

SIMILAR CAMERAS: ActionSampler Clear (p 14)

VARIANT MODELS: —

The SuperSampler is distinct from other multi-lens cameras because its four lenses are arranged in a row rather than a grid. This gives four movie-like wide-screen images.

This camera was born from the idea that it could be used where the action is. To wind the film on, you pull a string of the type you usually find on a toy. This mechanism gives you the advantage of being able to wind it on by pulling the string with your teeth, which is particularly handy when you are cycling or taking part in a sport for which you need to have one hand free.

There are two speed settings: one takes exposures over the space of 2 seconds, and a super-quick mode takes them over a period 0.2 seconds. The shutters fire in sequence from the bottom up (the top of the camera being where the shutter release is). This means that if you move the camera upwards, "scanning" your subject, you can capture a mini montage that fits roughly together.

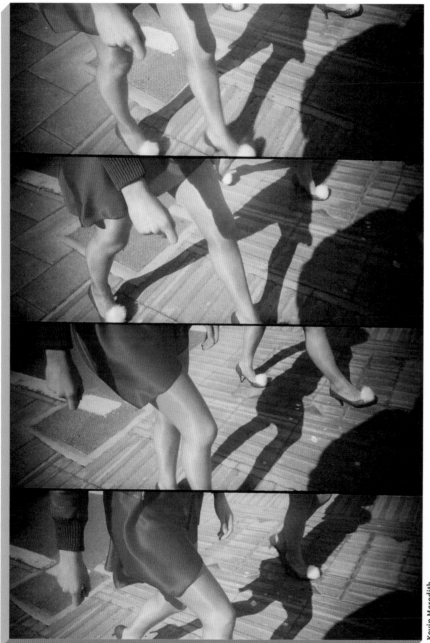

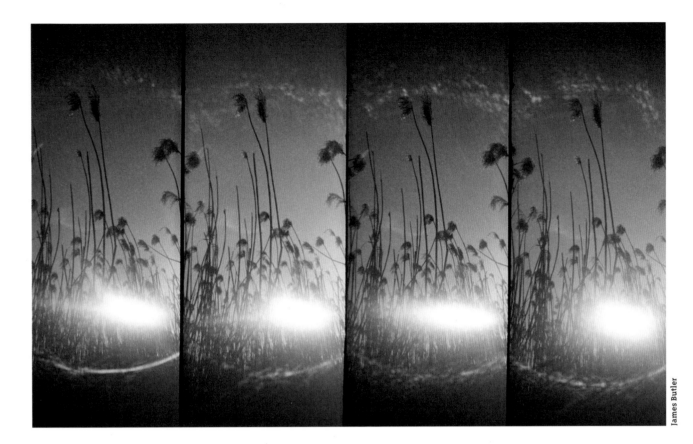

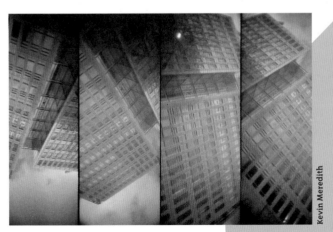

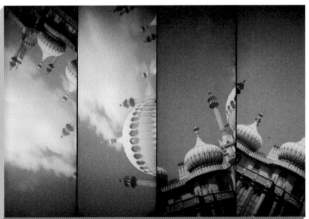

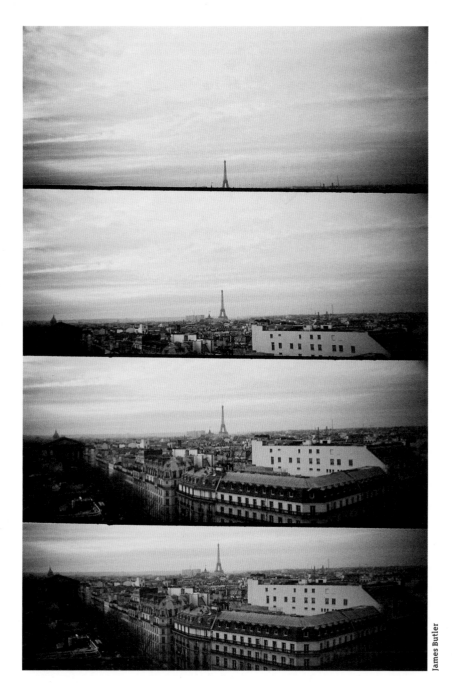

James Butler

Tony Kemplen, converted to black-and-white in post-processing

James Butler, cross-processed

DIANA F+ & CLONES

MEDIUM: 120 film, Fuji Instax film (with Instant Back), or 35mm film (with 35mm Back)

ISO RANGE: All ratings available

LENS: plastic, 20mm, 38mm, 55mm, 110mm, or pinhole

FOCUS: manual, range depends on lens

FLASH: Diana Flash or standard flashes via hot shoe adapter

APERTURE: f/11, f/16, f/22, or f/150

SHUTTER SPEED: 1/60 sec, or B (bulb)

SIMILAR CAMERAS: Holga CFN 120 (p 8) / No. 2 Portrait Brownie (p 62) / Holga

VARIANT MODELS: Diana Mini (p 70) / Diana Multi Pinhole Operator (p 110) / Diana+ / Diana F+ without flash

In addition to light leaks and vignetting, images taken on the Diana F+ often have a soft focus and interesting color shifts.

If you buy a Diana F+, you get more than just a camera; you get a system you can build on. Its range of accessories makes it one of the most versatile plastic cameras there is. The original Diana, on which the Diana F+ is modeled, was manufactured from the 1960s to the mid-1970s. It was cheap and sometimes free—given away as a promotional item. However, in the early 2000s it obtained a cult following and its price rocketed.

The Diana F+'s modifications include interchangeable lenses, among them a pinhole option. You can also choose to set the shutter to stay open so you don't have to keep it held open during long exposures. There is a range of four lenses; a cable release; and a flash that looks like the original but has had the electronics redesigned.

You can even change the format in which you shoot with two accessories: the Instant Back allows you to shoot Fuji Instax film, and the 35mm Back allows you to use 35mm film. Shots taken with 35mm film have a really rough-and-ready feel because the sprocket holes are exposed.

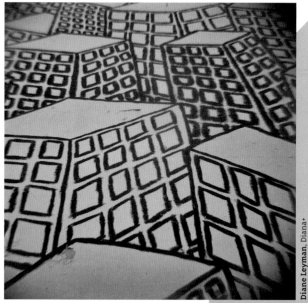

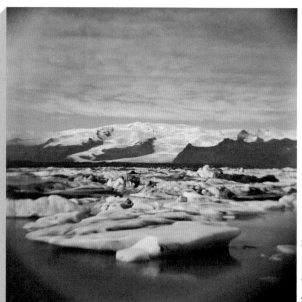

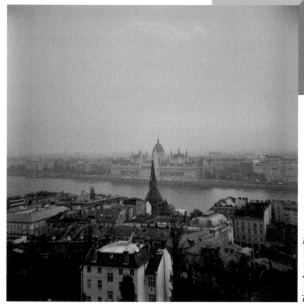

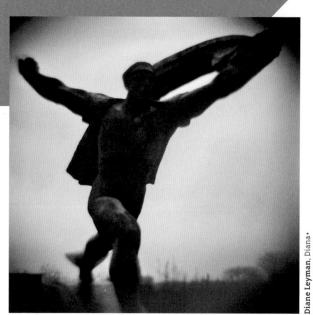

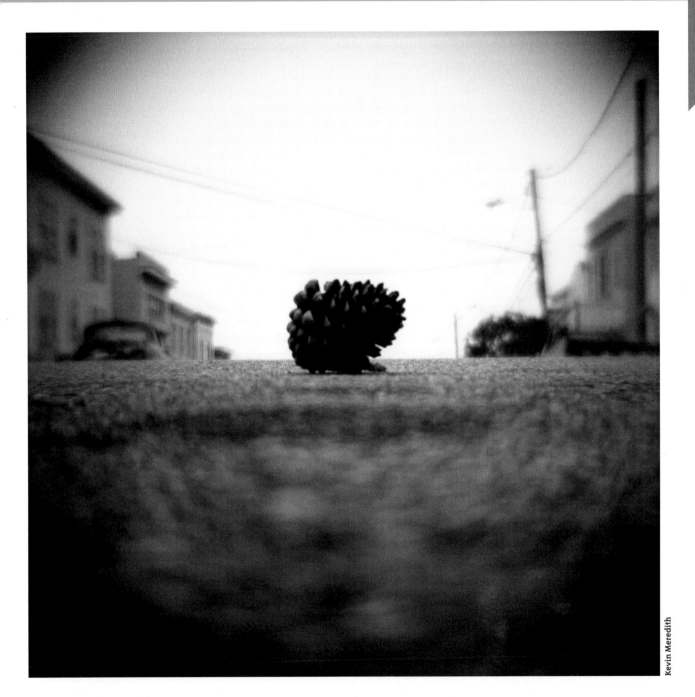

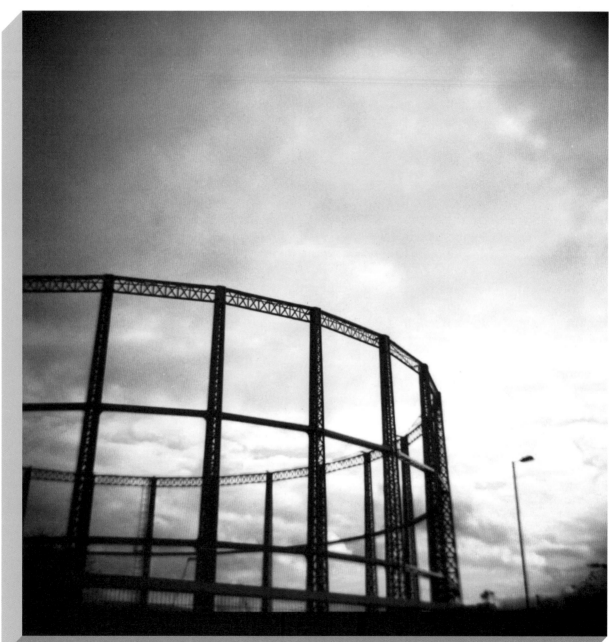

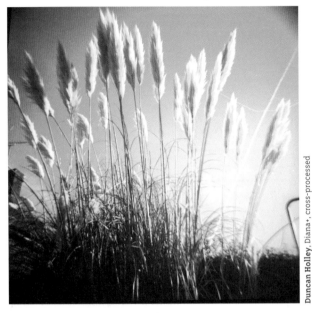

Duncan Holley, Diana+, cross-processed

Kevin Meredith

Kevin Meredith

Kevin Meredith, cross-processed

HIPSTAMATIC
& OTHER SMARTPHONE APPS

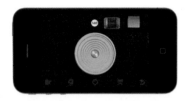

This camera-phone application can emulate any effect you desire: vignetting, color casts, action-sampling ...

MEDIUM: digital, in-phone

ISO RANGE: —

LENS: —

FOCUS: —

FLASH: —

APERTURE: —

SHUTTER SPEED: —

SIMILAR APPS: ever-expanding

VARIANT MODELS: —

There are hundreds of iPhone and other smartphone camera applications available, but the Hipstamatic stands out from the crowd—it turns an iPhone into a one-stop shop for simulated analog fun. Rather than producing flat-looking digital images, Hipstamatic emulates the analog look by adding vignetting, color casts, contrast, and borders. It allows you to select from different virtual lenses, films, and flashes, which all change the look of the final image. There are six lenses, eight film types, and six flashes, giving you a possible 336 different combinations— enough creative possibilities to keep you going for a while. The app on its own comes with three lenses, three film types, and two flashes; if you want further options, you need to purchase add-on packs. The app with all the add-ons costs less than a roll of film and development would, so it's well worth getting if you have an iPhone.

There are two settings for Hipstamatic: low and high quality. Low quality is great for showing off images on your phone and on some websites, but if you want to print, you have to go for the high-quality option (1200 pixels), which is good enough to print at 4 × 4in (10 × 10cm). The only drawback with using the high-quality mode is that it takes a lot longer for the phone to process an image and allow you to shoot again.

For fans of action-sampling cameras there is the QuadCamera app. This takes a series of pictures in rapid succession, then arranges them in a grid. You can select the type of grid you want to use: a row of 4 or 8, or a 2 × 4 or 4 × 4 grid. A great feature of this app is that you can set the interval at which your pictures are taken to be anything from 1/10 sec to 3 seconds.

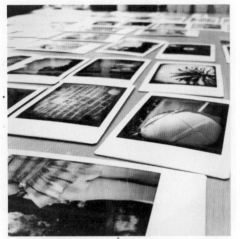

Kevin Meredith, Alfred Infrared film, Helga Viking lens

Kevin Meredith, Float film, Roboto Glitter lens

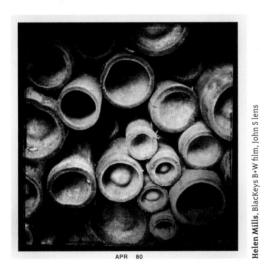

Helen Mills, Blackeys B+W film, John S lens

Petter Båtsvik Risholm, Alfred Infrared film, John S lens

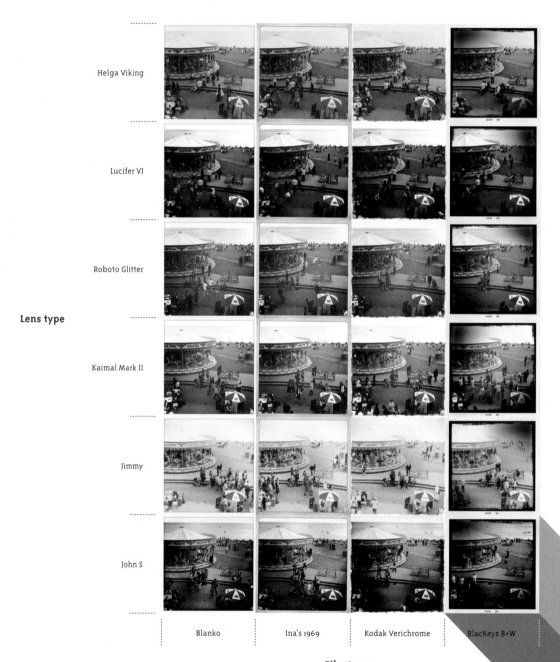

Lens type

Helga Viking

Lucifer VI

Roboto Glitter

Kaimal Mark II

Jimmy

John S

Blanko Ina's 1969 Kodak Verichrome BlacKeys B+W

Film type

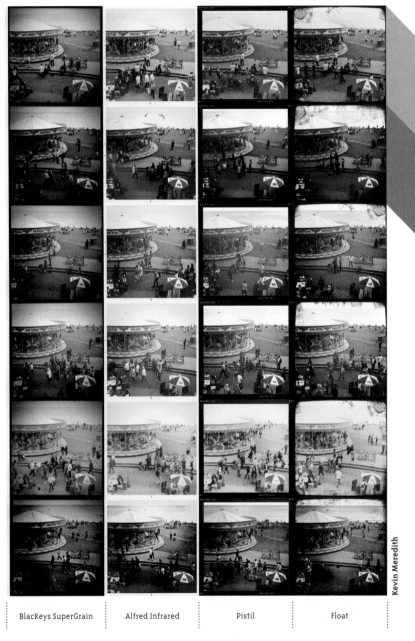

| BlacKeys SuperGrain | Alfred Infrared | Pistil | Float |

Film type

Kevin Meredith

Emily Portnoi, Ina's 1969 film, Jimmy lens

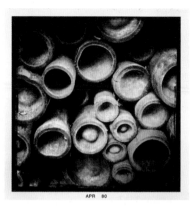

APR 80

Helen Mills, BlacKeys B+W film, John S lens

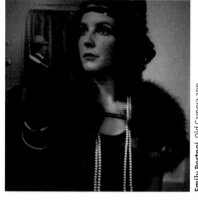

Emily Portnoi, Old Camera app, Hicon B+W filter, vignetting

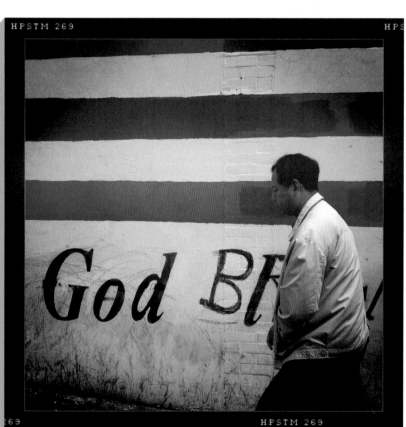

HPSTM 269

HPS

269

HPSTM 269

Kevin Meredith, Pistil film, Roboto Glitter lens

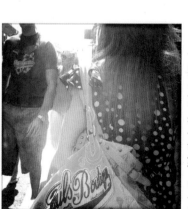

Kevin Meredith, Kodak Verichrome film, Kaimal Mark II lens

Kevin Meredith, Blanko film, Roboto Glitter lens

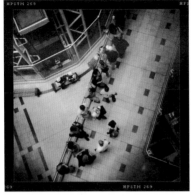

Kevin Meredith, Pistil film, Lucifer VI lens

Helen Mills, Pistil film, John S lens

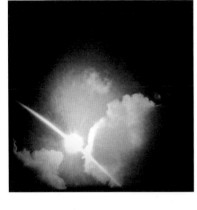

Mario Perez, BlacKeys Supergrain film, John S lens

Mario Perez, BlacKeys Supergrain film, John S lens

Helen Mills, BlacKeys B+W film, John S lens

Emily Portnoi, Pistil film, Kaimal Mark II lens

Emily Portnoi, Ina's 1969 film, John S lens

Mario Perez, BlacKeys B+W film, John S lens

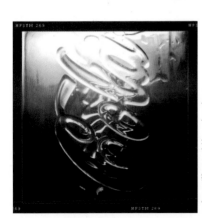

Helen Mills, Pistil film, John S lens

ULTRONIC PANORAMIC

MEDIUM: 35mm film

ISO RANGE: All ratings available

LENS: fixed, 28mm

FOCUS: 80cm (2½ft) to infinity

FLASH: —

APERTURE: fixed, f/11

SHUTTER SPEED: fixed, 1/125 sec

SIMILAR CAMERAS: Spinner 360° (p 34) / Ansco PIX Panorama / Horizon

VARIANT MODELS: —

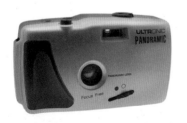

Ultronic Panoramic images are known for their black bands top and bottom, and extreme blurring left and right.

. .

The Ultronic Panoramic is not a true panoramic camera; it simply masks the top and bottom of the negative. This means that when you get your negatives scanned or printed there is a black bar at the top and bottom of your photos. Some photo labs can create panoramic prints on wider paper, but many don't offer this option. As with a lot of images produced by a low-quality lens, the center tends to be sharper than the edges and this is particularly obvious with the Ultronic Panoramic because cropping the slightly blurred top and bottom makes the left and right edges look *really* blurred. This makes for an interesting framing mechanism and can help draw your eye to the center of the image.

The Ultronic Panoramic is great for capturing cityscapes and landscapes as it lets you shoot a skyline without getting too much sky or foreground. This is good because its lack of a flash means it is best suited to outdoor use.

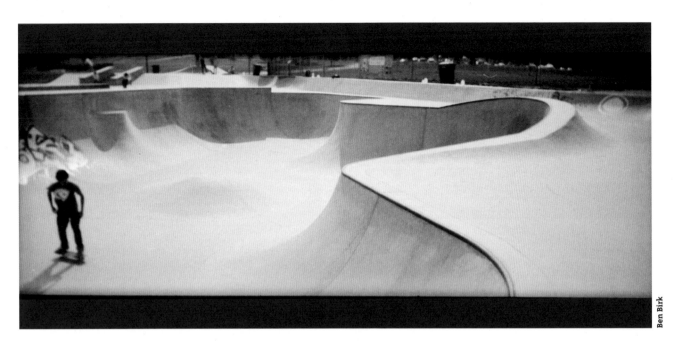

Kevin Meredith

Farzad Qasim

Kevin Meredith, cross-processed

Kevin Meredith

Kevin Meredith

Kevin Meredith, cross-processed

Kevin Meredith

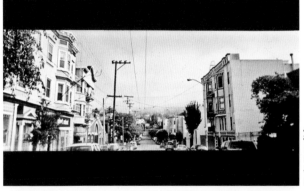

Kevin Meredith

Ben Birk

Kevin Meredith

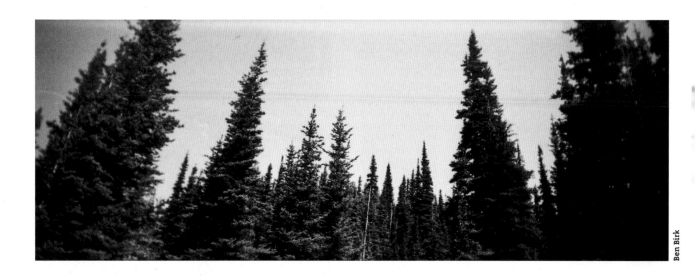

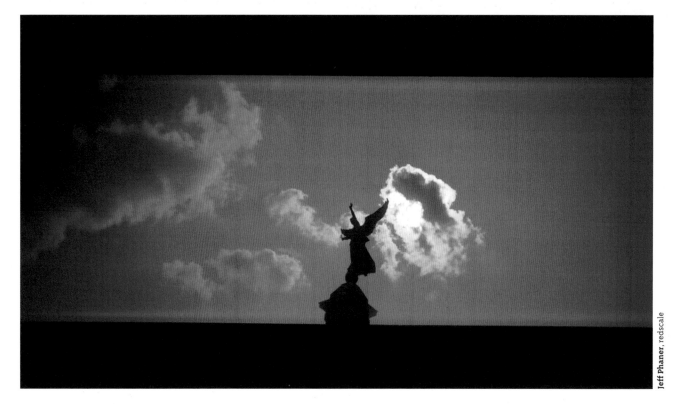

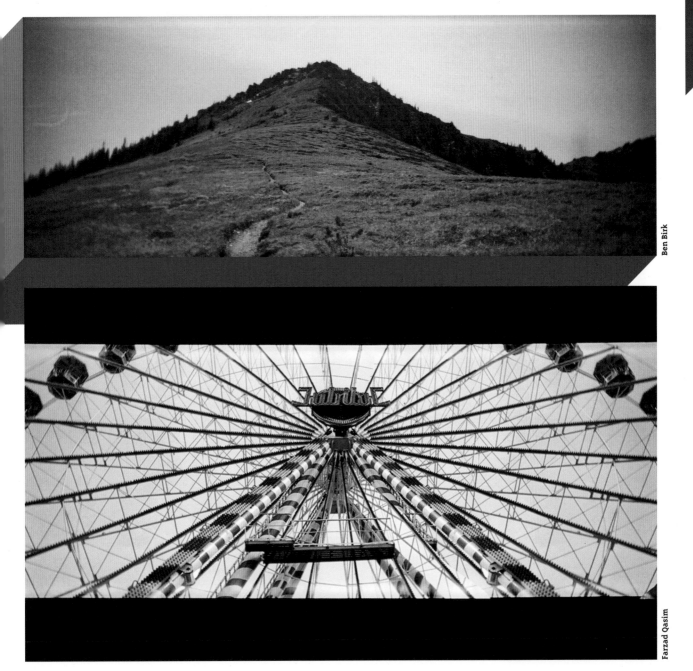

Ben Birk

Farzad Qasim

BOKEH MASTERS KIT

MEDIUM: —

ISO RANGE: —

LENS: —

FOCUS: —

FLASH: —

APERTURE: —

SHUTTER SPEED: —

SIMILAR KITS: Lensbaby Creative Aperture Kit

VARIANT MODELS: Bokeh Advanced Kit / Bokeh Demo Kit

With the Bokeh Masters Kit you can turn blurred points of light in a photograph into a range of different shapes.

An accessory rather than a toy camera, this kit is designed for use with DSLRs. It consists of a disc holder, 20 discs with different shapes cut into them, and eight blank discs into which you can cut any shape you want. The kit works with a range of lenses (as long as the filter size is 62mm or smaller—otherwise the disc won't cover the end of the lens) but is at its best with wide apertures, as these give you the most blurring in your images.

To attach the kit, you simply fold its three legs around your lens and secure it with an elastic band. You can then easily swap discs to get the shapes you want.

If you just want to try this technique out, or you don't want all 28 discs, there are cheaper kits available. The Advanced Kit comes without the blank discs and the Demo Kit, a very basic version, comes with just five ready-cut discs. All of these kits come housed in a cardboard envelope, so you can leave them in your camera bag (they don't take up much room) and get them out as the mood strikes.

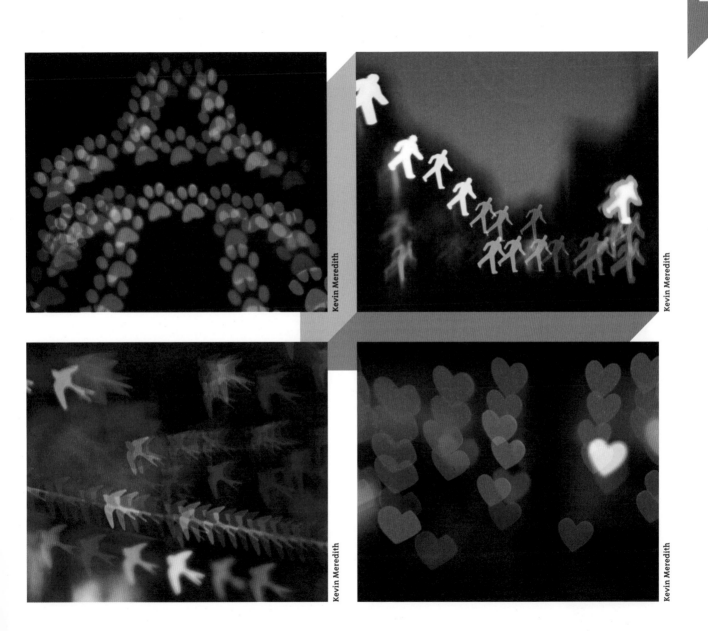

Kevin Meredith

Kevin Meredith

Kevin Meredith

Kevin Meredith

NO. 2 PORTRAIT BROWNIE

MEDIUM: 120 roll film

ISO RANGE: All ratings available

LENS: not specified

FOCUS: Portrait (close-up) or Landscape (infinity), not specified

FLASH: —

APERTURE: cloudy, partly cloudy, or sunny

SHUTTER SPEED: 1/25 sec or B (bulb)

SIMILAR CAMERAS: Holga CFN 120 (p 8) / Diana F⁺ (p 42) / Holga

VARIANT MODELS: Models include: Brownie / No. 2 Brownie / No. 2 Brownie Junior / No. 2 Beau Brownie / No. 2A Beau Brownie / No. 2A Brownie

Portrait Brownie images often have a vintage feel to them, especially with black-and-white film, and tend to be very sharp compared with other toy cameras.

Being the first affordable camera, I think, makes the Brownie the original toy camera: for the first time photography was possible without expensive professional gear. The camera operation is dead simple—just select your aperture according to whether it is sunny or cloudy—and the glass lens gives you a sharper image than the usual plastic lens of a 120 toy camera.

The Portrait Brownie is so named because the viewfinder has a portrait orientation. You can twist it 90° to make it landscape, but this does make it a little more difficult to release the shutter.

If you are looking for a Brownie, make sure you get one that takes 120 roll film, as many take obsolete film formats. You can roll the film onto a new spool that the camera will take, but it is easier if you start with a camera that takes 120 film.

You can find some Brownie models on eBay cheaply because they were made in such vast numbers, but you might not pick yourself up an original 1900s version at such a bargain price.

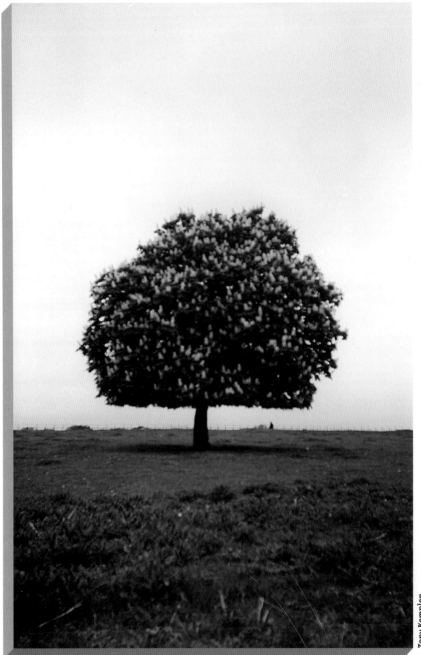

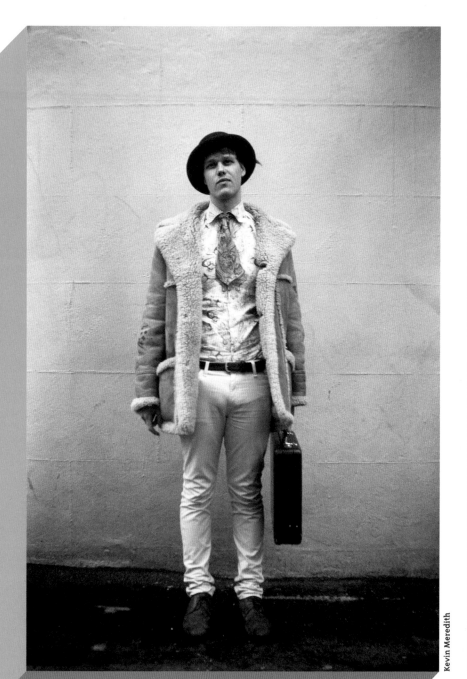

Kevin Meredith

Hannah Dennis

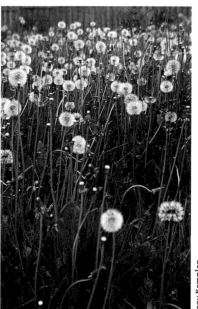

Tony Kemplen

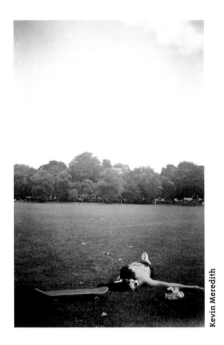

Kevin Meredith

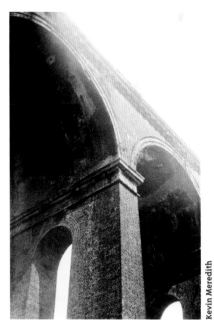

Kevin Meredith

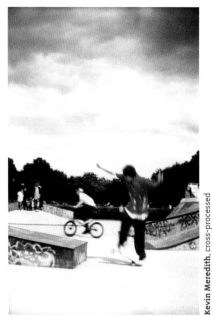

Kevin Meredith, cross-processed

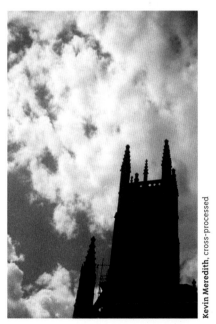

Kevin Meredith, cross-processed

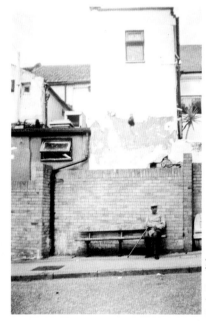

Kevin Meredith

Tony Kemplen

SHIRONEKO HOLGA

MEDIUM: 35mm film

ISO RANGE: All ratings available

LENS: 35mm

FOCUS: fixed, 1.5m (5ft)

FLASH: built-in

APERTURE: fixed, f/8

SHUTTER SPEED: not specified

SIMILAR CAMERAS: —

VARIANT MODELS: —

This odd-looking camera gives you sharp close-ups with a blurred background.

The Shironeko Holga was designed specifically for taking pictures of cats. When the button on the front is pressed, the camera makes cat noises ranging from meows to purring to some, quite frankly, crazy sounds that cat owners might find disturbing. The idea is that these sounds will grab your feline friend's attention and get him or her to look directly at the camera, which, as any cat owner knows, can be tricky. If the sounds are not attention-grabbing enough, there is also a bank of flashing green and red lights on the front of the camera. Although it was designed with cats in mind it works just as well with dogs, and humans seem quite curious about it too.

For a 35mm compact this camera is pretty huge. It's not one that will slip into your pocket or handbag comfortably. Its bulky looks have been toned down somewhat with the addition of a cute winking cat face on the front, with the camera lens as the open eye. Very Japanese!

Most compacts with a fixed focus will focus on anything from 3m (1ft) to infinity so that they can capture anything from a portrait to a landscape. The Shironeko Holga differs in that its focusing sweet spot is around 30cm (1ft). This means you can take close-up shots and what is in the background will be out of focus, which makes for great still-life photos.

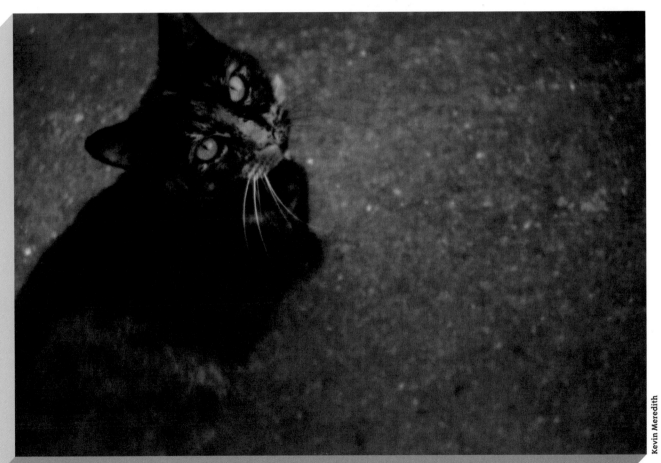

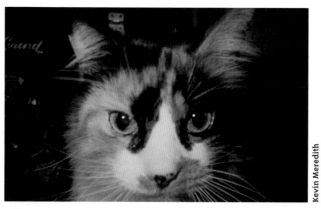

Kevin Meredith

Kevin Meredith

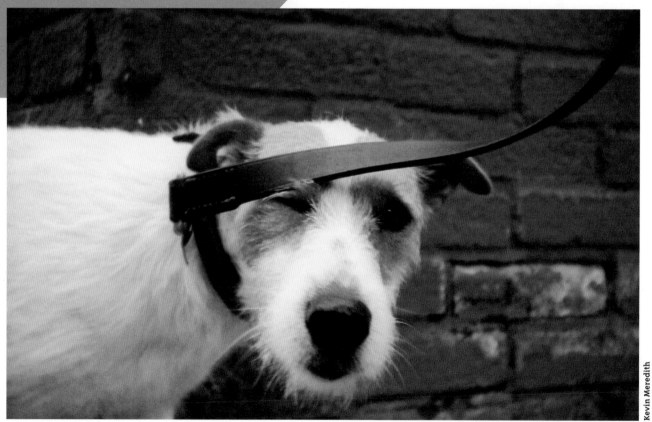

Kevin Meredith

DIANA MINI

MEDIUM: 35mm film

ISO RANGE: All ratings available

LENS: fixed, 24mm

FOCUS: 60cm (2ft), 1.2m (4ft), 2.4m (7⅞ft), or 4m (13ft) to infinity

FLASH: Diana flash and standard flash via adapter

APERTURE: f/8 or f/16

SHUTTER SPEED: 1/60 sec or B (bulb)

SIMILAR CAMERAS: Holga 135TIM / Golden Half (p 90) / Holga 135BC (p 150)

VARIANT MODELS: Diana F+ (p 42) / Diana Multi Pinhole Operator (p 110)

Along with light leaks, scratches, and color shifts, the Diana Mini offers you two formats: square and half-frame.

The Diana Mini makes a great first camera for anyone who wants to dabble with film but doesn't want to deal with the expense of the 120 format, and its size makes it a great everyday and everywhere companion. The little sister of the Diana F+, it takes 35mm film, making it cheaper to shoot on than the Diana F+, which takes 120 film. The Diana Mini allows you to shoot in one of two formats: 17 x 24mm (which, being half the normal 35mm frame, gets you 72 exposures from a 36-exposure film) or 24 x 24mm (which is very close to the square format of the Diana F+ and gives you 36 exposures). And you can swap between these formats on the same roll.

As with its big sister, it is very easy to shoot multiple exposures on the Diana Mini—you simply press the shutter button repeatedly. This opens up new possibilities because, if you so choose, you can partly wind on the film, take a shot, and repeat to build up a layered effect across multiple images. The Diana Mini is also well suited to long exposures because it allows you to use a cable release. You can even use the Diana F+'s retro-looking flash on it; this looks super crazy as it dwarfs the camera. In shrinking the Diana down to its Mini size, the removable lens and partly cloudy setting were lost—the Mini has only sunny and cloudy aperture settings.

Kevin Meredith, cross-processed

Michelle Kaplow

Michelle Kaplow

Michelle Kaplow, cross-processed

Michelle Kaplow, redscale

Christopher Evans, expired film

Kevin Meredith, overlapping frames

Michelle Kaplow, cross-processed

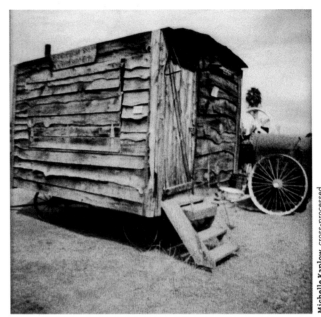

Michelle Kaplow, cross-processed

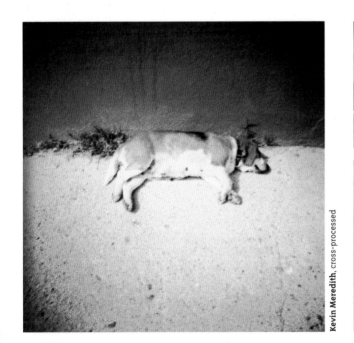

Kevin Meredith, cross-processed

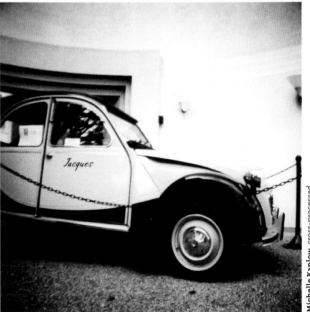

Michelle Kaplow, cross-processed

ACTIONSAMPLER FLASH

MEDIUM: 35mm film

ISO RANGE: All ratings available

LENS: fixed, 26mm

FOCUS: fixed, 1.2m (4ft) to infinity

FLASHES: four, built-in

APERTURE: fixed, not specified

SHUTTER SPEED: fixed, 1/100 sec

SIMILAR CAMERAS: Aryca (p 96) / Oktomat (p 114) / Kalimar Action Shot 16 (p 146)

VARIANT MODELS: ActionSampler Clear (p 14)

This camera adds the option of backlighting to the ActionSampler's characteristic off-kilter exposure, motion blurring, and oversaturated colors.

The ActionSampler Flash has four flashes that fire in time with each exposure. This opens you up to a new world of creative possibilities. One of the major drawbacks with multiframe cameras is that they generally only work in good lighting conditions and bright sunlight. You can use fast film (ISO 800 or higher) to get shots in low light, but there is a limit to how dark you can go. This is where the ActionSampler Flash steps in.

You can use the camera without the flashes, but turning them on is simple—just flip and turn the flash head so it faces forward. This ensures that the flash can't be triggered accidentally. It's a great camera if you are going out partying and want to capture the essence of your night out. The flashes can also be used during the day to light up backlit subjects. Sometimes when the camera or subject is moving really fast you get some motion blur in the pictures, but with the aid of the flash, it is possible to freeze parts of the image while retaining motion blur.

A great way to modify the ActionSampler Flash is to cover each flash with a different colored gel. You can cut sections from a sample gel book, stick them together and then fix them over the camera's flash with adhesive tape. The resulting images are mini pop-art masterpieces with each image having a different color cast.

Kevin Meredith, red, yellow, and orange gels

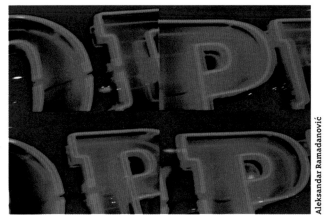

Kevin Meredith

Aleksandar Ramadanović

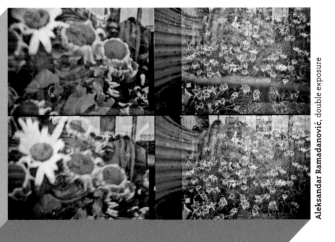

Aleksandar Ramadanović, double exposure

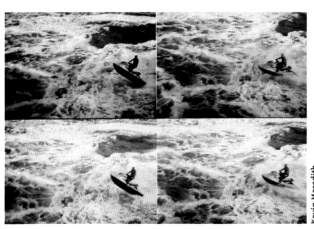

Kevin Meredith

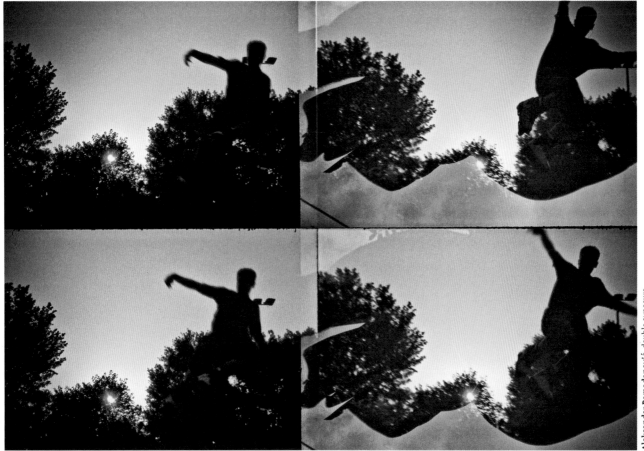

Aleksandar Ramadanović, *double exposure*

DIGITAL HARINEZUMI 2

This digital camera gives you the "imperfections" of high contrast, oversaturated colors, and blurring.

With the Digital Harinezumi 2 you can switch from film to digital in a modern-retro kind of way. The Harinezumi follows the toy camera rather than the digital camera model in one important way: when you take pictures, you don't get a live view on an LCD screen; you compose your shot in a plastic viewfinder and are shown the image only once you have taken it.

In addition, you can select either 100 or 800 ISO. This is odd, as a digital camera would normally let you select all the steps in between, but it does make the camera much easier to use—if it's bright you select 100 and if it's dark, 800. Simple!

The camera's tiny lens, combined with its offbeat image processor, lets a lot of intentional imperfections show up in the images, including oversaturated colors, high contrast, and blurring—not the type of thing you normally get from a compact digital camera.

Another great thing with the Harinezumi 2 is that it takes the SD memory cards usually used with cell phones. Its resolution is only 3 megapixels, but this is good enough for 6 × 4in prints. A final bonus is that it also shoots video with the look of 8mm film. Up to two hours of footage can be stored on a 2GB SD card.

MEDIUM: digital, micro SD cards

ISO RANGE: 100 to 800

LENS: fixed, plastic, 24mm

FOCUS: 1m (3¼ft) to infinity; macro: c. 10cm (4in)

FLASH: —

APERTURE: fixed, f/2.8

SHUTTER SPEED: not specified

SIMILAR CAMERAS: VistaQuest VQ1005 Digital Keychain Camera

VARIANT MODELS: Digital Harinezumi

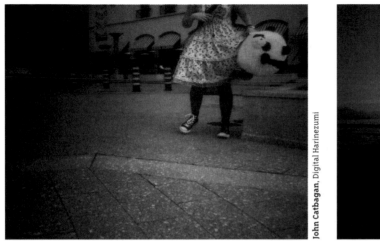

John Catbagan, Digital Harinezumi

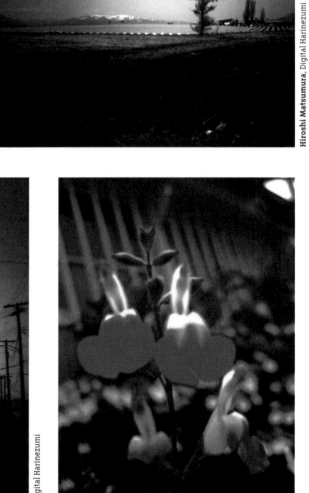

Hiroshi Matsumura, Digital Harinezumi

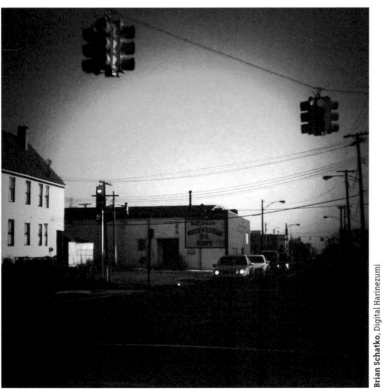

Brian Schatko, Digital Harinezumi

Yusuke T

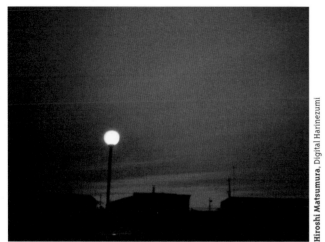

Hiroshi Matsumura, Digital Harinezumi

John Catbagan, Digital Harinezumi

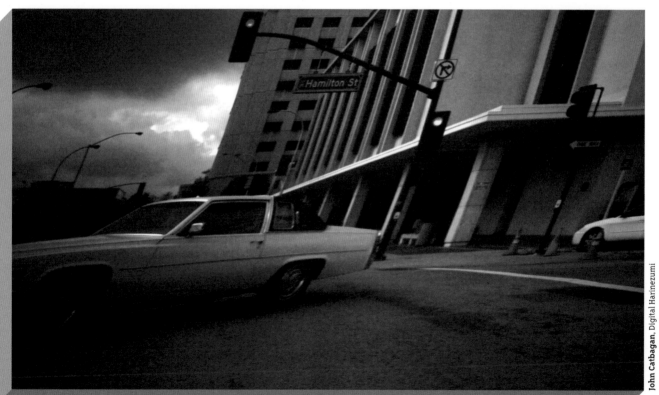

John Catbagan, Digital Harinezumi

SPLIT-CAM

MEDIUM: 35mm film

ISO RANGE: All ratings available

LENS: not specified

FOCUS: 1m (3¼ft) to infinity

FLASH: —

APERTURE: not specified

SHUTTER SPEED: not specified

SIMILAR CAMERAS: Lomo LC-A+ (p 22) with Splitzer

VARIANT MODELS: —

Fuzzy seams are the hallmark of the Split-Cam's overlapping images.

The Split-Cam gives you the ability to mask off selectively either the top or the bottom half of the frame. The idea is to mask off the top half, take a picture, then mask off the bottom half and shoot again, giving you two overlapping images on the same exposure.

This allows you to mix what goes in the top and bottom of an image, so you could shoot a person's body, then set a dog's head on their shoulders. Because the mask is in front of the lens, you a get a really fuzzy blend between the images. There is quite a lot to do on this camera—you have to move the masks on both the viewfinder and the lens. If you forget to move one of them, and that is easily done, you end up with a shot that is half black.

As I am so used to manual cameras of this type, I have found myself winding the film on before taking my second shot!

Rather than go for the obvious, you can get really creative. Start shooting things in perspective, change the mask, rotate the camera, and shoot the same thing again so that you create mirrorlike effects. You control which part of the image you obscure; you can choose not to move the masks at all and just use the camera to create simple double exposures.

The camera is large, its design is very basic, and half of it is painted yellow, which would give it an industrial feel were it not for the fact that it is made of plastic.

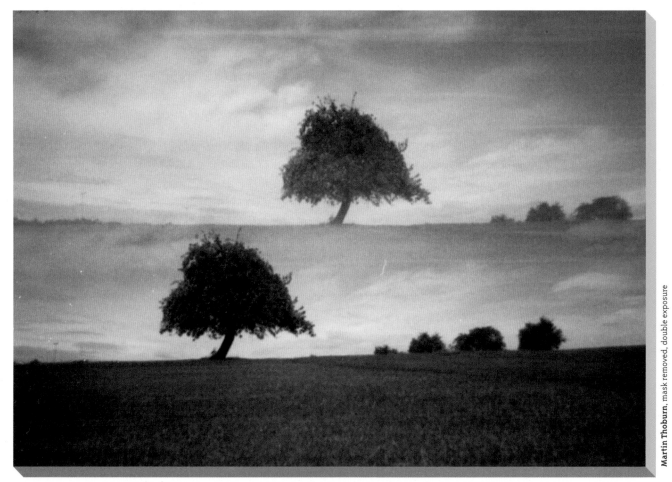

Martin Thoburn, mask removed, double exposure

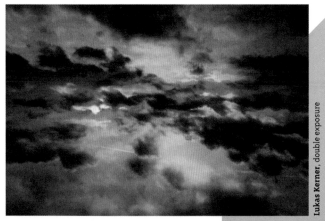

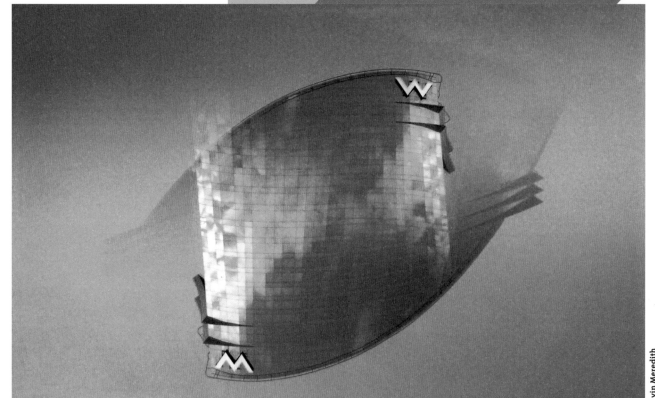

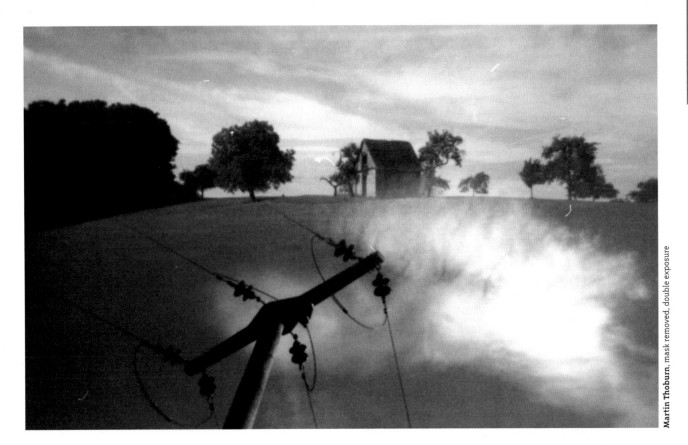

Martin Thoburn, mask removed, double exposure

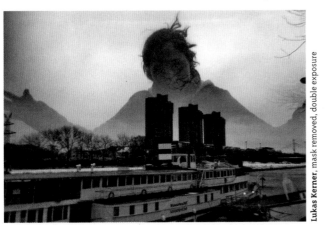

Lukas Kerner, mask removed, double exposure

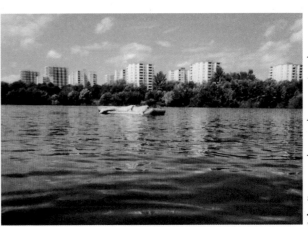

Lukas Kerner, mask removed, cross-processed

VIVITAR ULTRA WIDE & SLIM

MEDIUM: 35mm film

ISO RANGE: All ratings available

LENS: fixed, plastic, 22mm

FOCUS: 30cm (12in) to infinity

FLASH: —

APERTURE: fixed, f/11

SHUTTER SPEED: fixed, 1/125 sec

SIMILAR CAMERAS: Pop-Tarts camera (p 156) / Eximus Wide & Slim / White Slim Angel / Black Slim Devil

VARIANT MODELS: —

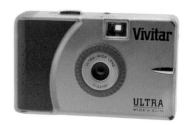

Not surprisingly, this camera gives you a particularly wide view along with vignetting and high color contrast.

The Vivitar Ultra Wide & Slim (UWS) is a true toy camera, with a build quality comparable to that of a disposable 35mm camera. When they first became popular in 2007 they were very cheap, but in a matter of years their price had increased more then tenfold.

This camera is basic to say the least. It has a 22mm plastic lens and a shutter button with a film winder ... and that's it. The characteristic lens-flare—which can look great with silhouette shots when the flare overlaps the silhouettes—is due to this plastic lens. The aperture is constant at f/11, which ensures a wide depth of field: everything from 30cm (12in) in front of the lens to infinity is in focus.

The wide lens frees you from using the viewfinder—you can be quite confident that anything you point at will be in the shot. And, being totally plastic, it doesn't weigh a thing.

One of the drawbacks with the UWS is that you are restricted to what speed film you can use because both the shutter speed and aperture are fixed. Another is that you need a decent lab for developing; because of the set exposure, a lot of the pictures will be under- or overexposed to some degree, and that will need to be compensated for in scanning or printing.

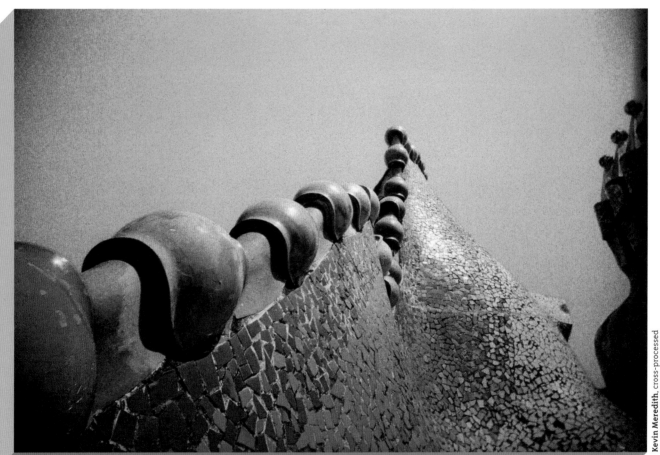

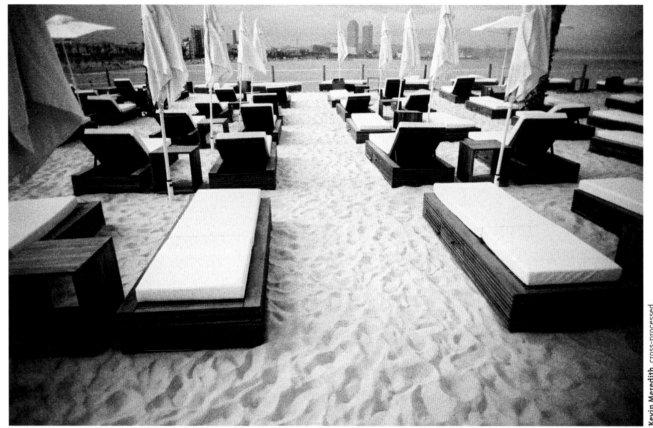

Kevin Meredith, cross-processed

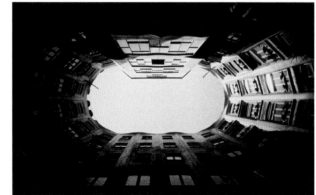

Kevin Meredith, redscale

Kevin Meredith, cross-processed

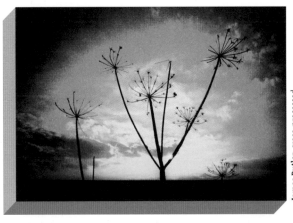

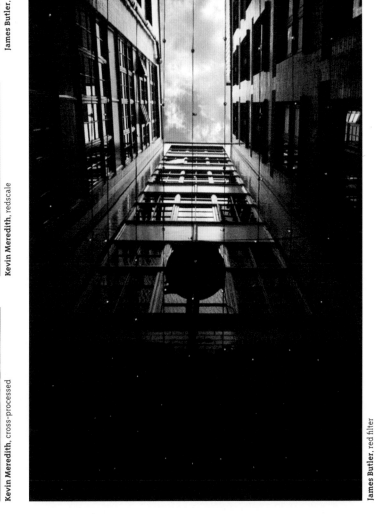

James Butler, cross-processed

Kevin Meredith, redscale

Kevin Meredith, cross-processed

James Butler, red filter

GOLDEN HALF

MEDIUM: 35mm film

ISO RANGE: All ratings available

LENS: fixed, 22mm

FOCUS: fixed, 1.5m (5ft) to infinity

FLASH: hot shoe to take flash

APERTURE: f/8 or f/11

SHUTTER SPEED: 1/100 sec

SIMILAR CAMERAS: Diana Mini
(p 70) / Nickelodeon PhotoBlaster /
Holga 135TIM

VARIANT MODELS: —

The Golden Half is unusually sharp for a half-frame toy camera, and plays down the typical toy camera aesthetic. Its two images are separated by a thick black divider.

The Golden Half is a great camera to have with you all the time because of its size—it is the smallest 35mm camera in this book—and because it halves the cost of development and scanning. A half-frame camera, it squeezes 72 exposures from a 36-exposure film, making it half the price of a normal 35mm camera to "run." It is also a great party camera. You can use it with a flash and shoot loads of pictures as the night progresses without having to worry about cost or reloading because you get twice the number of exposures. The only drawback with shooting half-frame is that your pictures will be of a lower quality than full-frame images. However, this quality issue only really matters if you want to blow up the results—standard 6 × 4in images will look fine.

When you get your prints and scans back from the lab, you will have two pictures on each frame. This makes it a great little camera for shooting diptychs: two images that share a theme or subject. I find that you are better off shooting triptychs (sets of three) as this gives you a much better chance of getting two of the same thing on some of the frames, and on the others you will have two contrasting images. If you try to shoot only diptychs, you run the risk of getting a whole bunch of mismatched images.

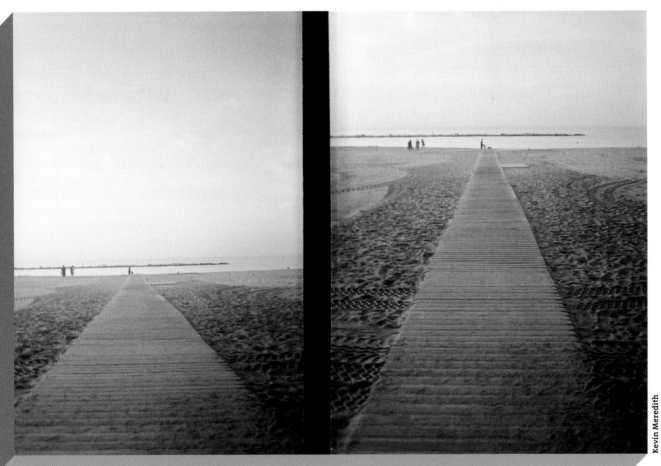

Kevin Meredith

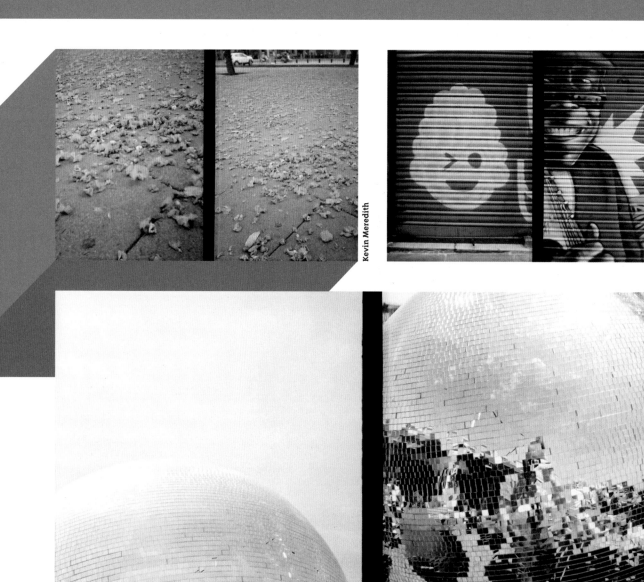

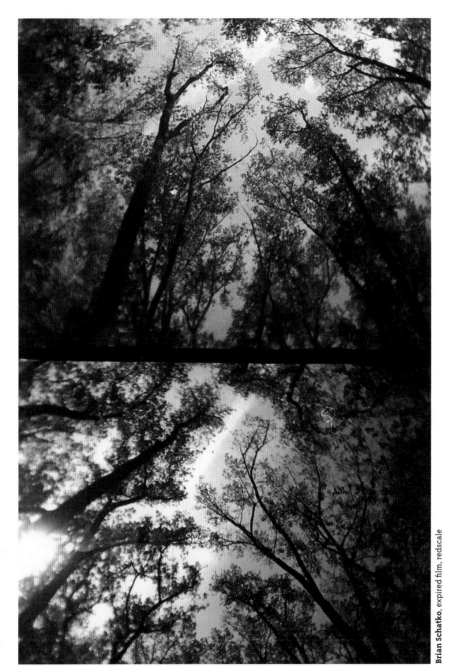

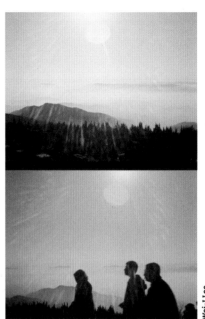

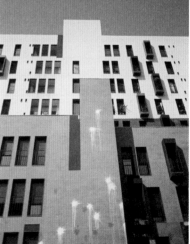

Brian Schatko, expired film, redscale

Wei-I Lee

Kevin Meredith

FISHER-PRICE KID-TOUGH

MEDIUM: digital, built-in, expandable with SD cards

ISO RANGE: —

LENS: 4.8mm

FOCUS: fixed, 1.2m (4ft) to infinity

FLASH: auto

APERTURE: f/2.6

SHUTTER SPEED: —

SIMILAR CAMERAS: LEGO digital camera (p 154) / Vtech Kidizoom Multimedia / Nickelodeon PhotoBlaster

VARIANT MODELS: —

Low-resolution images are what you get from this indestructible camera.

∎ ∎

The Fisher-Price Kid-Tough was built with kids in mind. It is simple to use and resilient. Using it is an interesting experience; as you get to know its functionality, it becomes clear that all areas have been covered. It's great to see a camera designed for someone with no idea how to use one, or who is not familiar with the conventions of camera design. The Kid-Tough's unique feature is that it has two viewfinders. This means that, instead of having to close one eye to look through the viewfinder, which children might find tricky, you hold the whole camera to your face and look though both viewfinders, as you would with a pair of binoculars.

The image quality of the Kid-Tough's pictures is quite low—they have the feel of early camera-phone pictures, as the camera is only capable of capturing 1.3-megapixel images—but it is built to last. It has two huge rubber handgrips either side of the lens that protect both the LCD screen and the lens should the camera be dropped.

Kevin Meredith

Cheyenne K. Sprenger, Vtech Kidizoom

Cheyenne K. Sprenger, Vtech Kidizoom

Cheyenne K. Sprenger, Vtech Kidizoom

Kevin Meredith

Kevin Meredith

Kevin Meredith

Cody D. Sprenger

Cheyenne K. Sprenger, Vtech Kidizoom

ARYCA

MEDIUM: 35mm film

ISO RANGE: 100 to 400

LENSES: four, fixed, 30mm

FOCUS: fixed, 1m (3¼ft) to infinity

FLASH: built-in

APERTURE: fixed, f/9

SHUTTER SPEED: set automatically at 1/125 sec, 1/60 sec, or 1/6 sec

SIMILAR CAMERAS: ActionSampler Clear (p 14) / ActionSampler Flash (p 74) / Kalimar Action Shot 16 (p 146)

VARIANT MODELS: —

The Aryca, one of the most versatile of the action-sampling cameras, will give you four grainy images with white dividers.

The lenses are arranged in a 2 × 2 grid, like the original ActionSampler. You can set off the shutters all at once, individually (which means you could use it to squeeze 144 images out of a 35mm film), or two at a time. On top of that you can select one of three different timing modes, which allows you to set the shutters off over a period of between 1/2 and 2 seconds, and you can change the timings for each of the different shutters opening because they are set off electronically rather than mechanically. It is the only action-sampling camera to include a self-timer, which means you can set it on a tripod or another sturdy surface and get into the shot yourself.

However, its one flash can only be used with modes in which you set off the shutters individually, unlike the ActionSampler Flash, which has one flash for each lens. Apart from the Kalimar Action Shot 16, it is the only action-sampling camera that winds on the film automatically, which means you won't miss a photo opportunity because you forgot to wind on the film.

The Aryca has an underwater housing, which is a great accessory because it enables you to take an action-sampling camera into an environment where there is a lot of action.

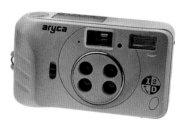

Chawee Busayarat

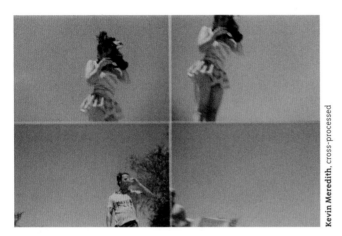

Kevin Meredith, cross-processed

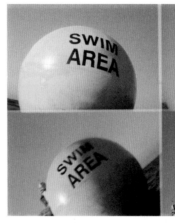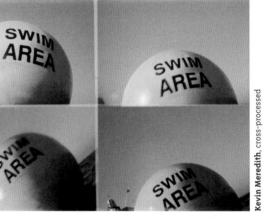

Kevin Meredith, cross-processed

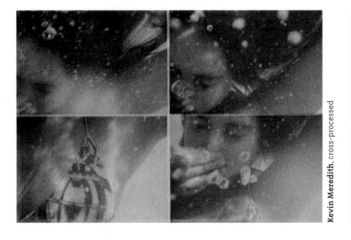

Kevin Meredith, cross-processed

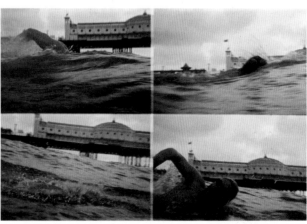

Kevin Meredith

BLACKBIRD, FLY

MEDIUM: 35mm film

ISO RANGE: All ratings available

LENS: fixed, 33mm

FOCUS: zone focus, 80cm (2½ft), 1.5m (5ft), 2m (6½ft), 2.5m (8ft), 3m (10ft), 4m (13ft), 5m (16½ft), 10m (33ft), or infinity

FLASH: hot shoe to take flash

APERTURE: f/7 or f/11

SHUTTER SPEED: 1/125 sec or B (bulb)

SIMILAR CAMERAS: Holga 135TLR

VARIANT MODELS: —

Images shot on a Blackbird, fly are very distinctive because they include a sprocket-hole trim.

The Blackbird, fly, a twin-lens reflex (TLR), shoots a conventional 36 exposures on a 36-exposure film but exposes the entire negative, including the sprocket holes (though you can, of course, crop these out). It has two lenses; you use one to compose your image and the other to take your shot. When I first saw the Blackbird, fly, I assumed it took 120 roll film because of its size and because most TLR cameras take 120 film, but it takes good old 35mm film—a much cheaper option.

It can be a really odd experience shooting with a TLR camera if you're not used to using one. You usually have to hold the camera at waist height and look down into the top of it to compose a picture, and it can be counterintuitive to use—

if you pan the camera horizontally, the image in the view screen moves the other way. This can be frustrating if you are trying to follow a moving object, as you will instinctively pan the camera in the same direction as the object only to find that it disappears out of frame. However, the Blackbird, fly is a great camera for taking low-down shots: because you look through the top of the camera, you don't have to get low yourself to compose a shot.

While most labs won't print or scan your image showing the sprocket holes, they will be able to give you cropped versions of your shots, allowing you to make an informed judgment about what is worth scanning yourself.

Kevin Meredith, cross-processed

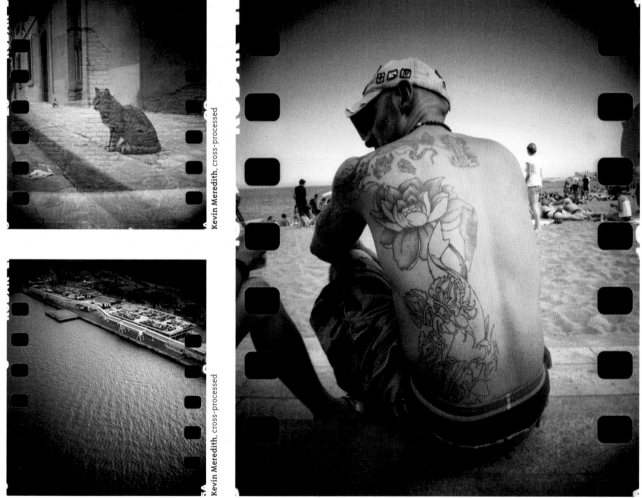

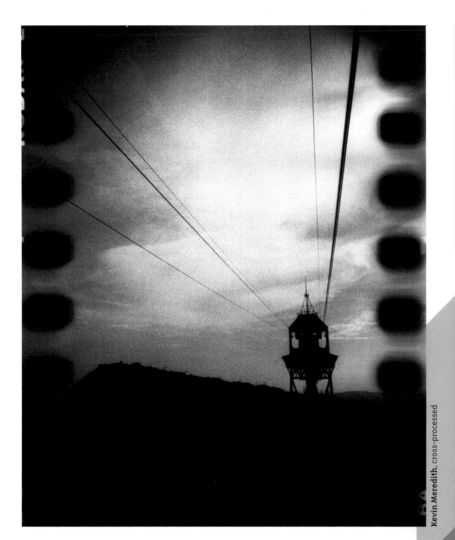

Kevin Meredith, cross-processed

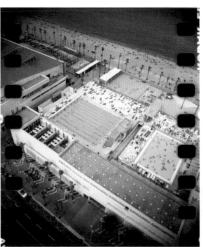

Kevin Meredith, cross-processed

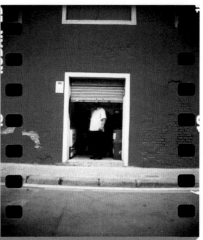

Kevin Meredith, cross-processed

FUJI INSTAX MINI 25

MEDIUM: Fuji Instax film

ISO RANGE: 800

LENS: fixed, 60mm

FOCUS: 50cm (1⁵/₈ft) to infinity; 35cm (1¹/₈ft) to 50cm (1⁵/₈ft) with close-up lens

FLASH: built-in, with Auto and Fill-in modes

APERTURE: f/12.7

SHUTTER SPEED: 1/3 sec to 1/400 sec

SIMILAR CAMERAS: Lomo LC-A+ (p 22) with Instax Back / Diana F+ (p 42) with Instax Back

VARIANT MODELS: Fuji Instax 210 / Fuji Instax Mini 7S

Faded colors, a wide depth of field, and a white border are all trademarks of the Fuji Instax Mini 25.

The Mini 25 is very simple to use, and its user-friendly features allow you to shoot instant perfection! It has two shutter buttons, which you select according to the orientation of your photo—landscape or portrait. You don't have to worry about focus, as everything from 50cm (1⁵/₈ft) to infinity is guaranteed to be in focus. If you want to go closer you can clip on a close-up lens. This allows you to dabble in macro photography, as it will let you focus on things just 35cm (1¹/₈ft) from the lens.

Another handy, but simple feature is its self-portrait mirror: when you turn the camera to face you, as long as you can see yourself in the little mirror, you know you will be in the picture.

The Mini 25's built-in flash is triggered automatically if the camera detects a dark scene, but you can switch this off by selecting the landscape orientation mode. You can also select the forced flash mode if you are shooting backlit scenes. Sometimes pictures taken with the flash can seem a little washed out, but I think that is part of the whole Instax aesthetic. And it's not a huge problem if you overexpose a shot as another of the camera's features is exposure control. If a shot is under- or overexposed, you can simply adjust the exposure and reshoot until you get what you want.

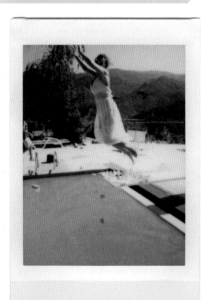

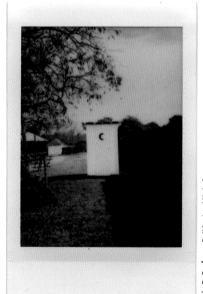

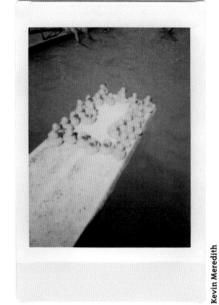

Kevin Meredith

Kevin Meredith

Kevin Meredith

Essie P. Graham, Fuji Instax Mini 7S

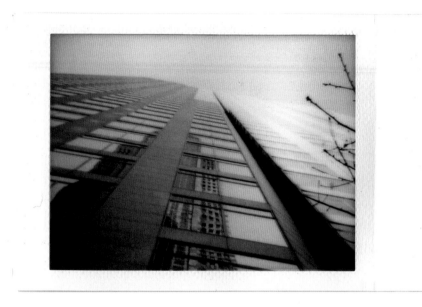

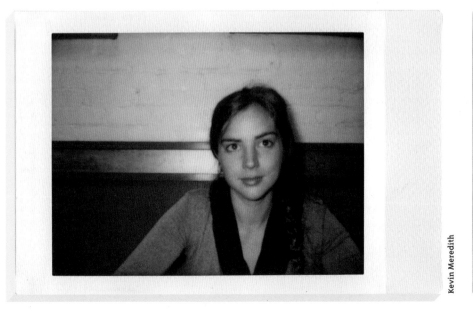

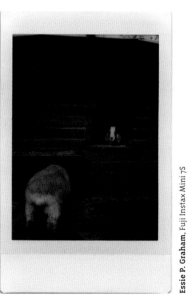

Kevin Meredith

Essie P. Graham, Fuji Instax Mini 7S

Essie P. Graham, Fuji Instax Mini 7S

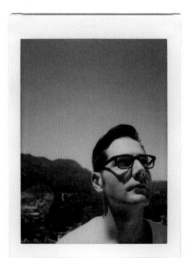

Kevin Meredith

COLORSPLASH CAMERA

MEDIUM: 35mm film

ISO RANGE: All ratings available

LENS: not specified

FOCUS: fixed, 80cm (2½ft) to infinity

FLASH: built-in

APERTURE: not specified

SHUTTER SPEED: 1/60 sec or B (bulb)

SIMILAR CAMERAS: Any with a hot shoe to take a Colorsplash Flash

VARIANT MODELS: —

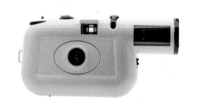

Ambient night light is a defining feature of images shot with the Colorsplash camera.

The Colorsplash camera really stands out from other toy cameras because of its shutter's bulb setting, which allows you to get creative with exposures and ambient light. In bulb mode the shutter opens when you press the shutter button and is only closed again when you release it. This means you can take long exposures at night. You can also achieve interesting effects with ambient light at night, and use the flash to freeze something in the frame. In bulb mode the flash will fire just before the end of the exposure.

With both the Colorsplash camera and the Colorsplash Flash, you simply turn a wheel to rotate through different-colored gels in order to select the color you want. These gels cover the flash, which has the effect of adding a color cast to anything lit up by it. The camera is equipped with three different-colored gels and a normal white flash, and you can swap these three colors with another nine gels that also come with it. Because the flashlight only reaches up to about 4.5m (15ft) from the camera, only objects close to you will have a color cast on them, and the color effect fades the farther away things are from the camera.

This is one of the best-looking toy cameras, in my opinion. In fact, I would go so far as to say it's one of the best-looking cameras, period. It looks as though it's from the future—the future if you were in the 1970s that is. It wouldn't look out of place in *Logan's Run* or *2001: A Space Odyssey*. Although its appearance is not important regarding its picture-taking abilities, it does help when you're trying to get people to pose for a photo, as they tend to be curious about its retro-futuristic aesthetic.

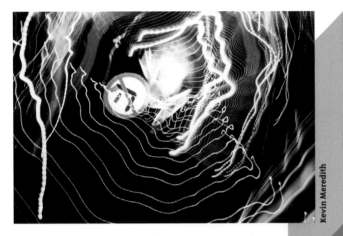

Kevin Meredith

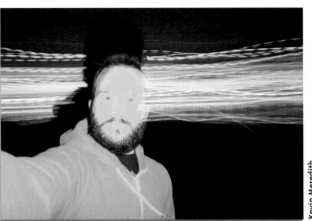

Kevin Meredith

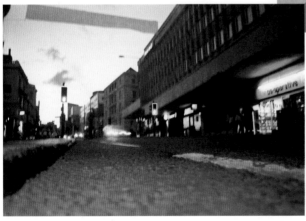

Kevin Meredith

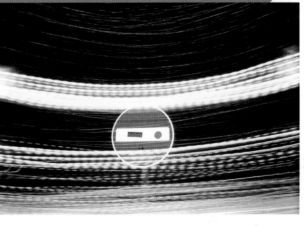

Kevin Meredith

DIANA MULTI PINHOLE OPERATOR

MEDIUM: 120 film; Fuji Instax (with the Diana Instant Back+) or 35mm film (with the Diana+ 35mm Back)

ISO RANGE: All ratings available

LENS: pinhole, with one-, two-, and three-hole options

FOCUS: fixed, 0m (0ft) to infinity

FLASH: Diana Flash (optional) or any hot shoe flash via the Hotshoe Adapter

APERTURE: f/128

SHUTTER SPEED: B (bulb)

SIMILAR CAMERAS: Hole-On Ex (p 122) / P-Sharan Wide-35 / P-Sharan SQ-35 / Science Museum Pinhole Camera

VARIANT MODELS: Diana F⁺ (p 42) / Diana Mini (p 70)

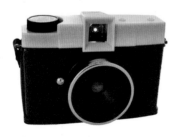

Diana Multi Pinhole Operator photos are easily spotted with their distinctive overlaid images and multiple color casts.

The Diana Multi Pinhole Operator (MPHO) takes pinhole photography to new levels. It gives you the option of three different settings: one hole, two holes side by side, or three holes arranged in a triangle. Pinhole cameras generally use one tiny "pinhole" as a lens. Taking shots with two or three pinholes produces photos with two or three images overlaid.

If these overlaid images aren't crazy enough for you, you can introduce one more level of madness by using the colored gels that come with the camera. These have two or three colors in them in order to cover each pinhole with a different color, casting a different tint over each of the overlaid images. One of the weird effects this can have is to make your photos look as though they are meant to be 3D because they look like the old red/green 3D images. Once you introduce colors, the images start to look like alien worlds or some strange animal's-eye view.

The MPHO is totally manual—you even have to open and then close the shutter manually, as with most pinhole cameras. You can use the Diana F as a pinhole camera by removing the lens and setting the aperture to P, but this will give you just one pinhole.

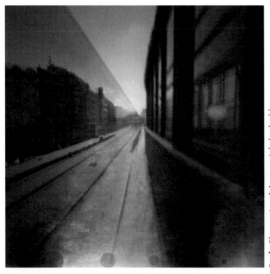

Paula Gimeno Aparicio, one pinhole, double exposure

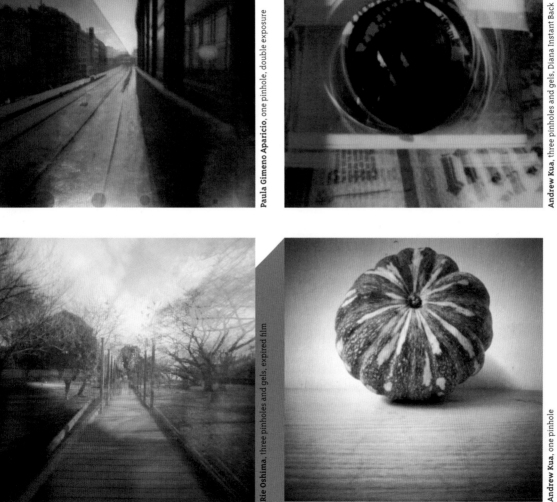

Andrew Kua, three pinholes and gels, Diana Instant Back

Rie Oshima, three pinholes and gels, expired film

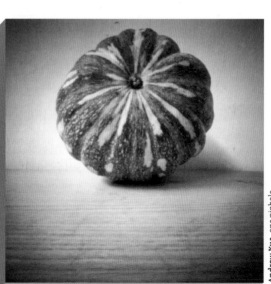

Andrew Kua, one pinhole

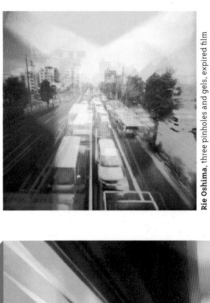

Rie Oshima, three pinholes and gels, expired film

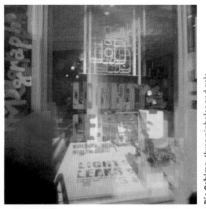

Rie Oshima, three pinholes and gels

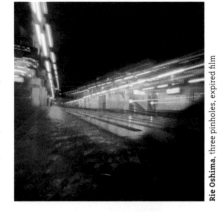

Rie Oshima, three pinholes, expired film

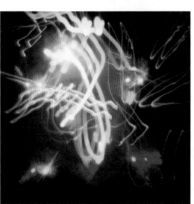

Kevin Meredith

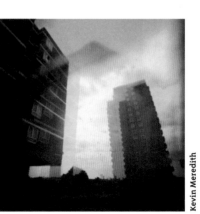

Kevin Meredith

Kevin Meredith

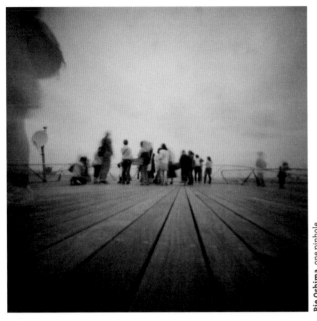

Rie Oshima, one pinhole

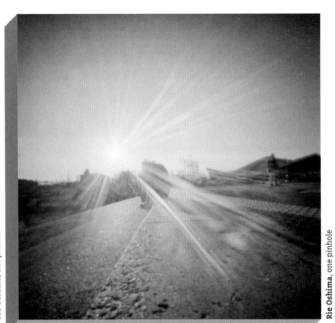

Rie Oshima, one pinhole

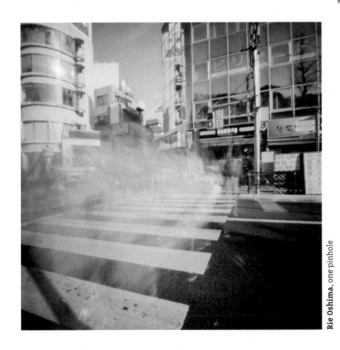

Rie Oshima, one pinhole

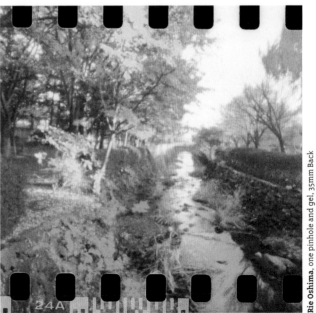

Rie Oshima, one pinhole and gel, 35mm Back

OKTOMAT

MEDIUM: 35mm film

ISO RANGE: All ratings available

LENSES: eight, plastic, mm not specified

FOCUS: not specified

FLASH: —

APERTURE: f/8

SHUTTER SPEED: 1/100 sec

SIMILAR CAMERAS: Aryca (p 96) / Kalimar Action Shot 16 (p 146)

VARIANT MODELS: —

The Oktomat's images have twice the number of frames of most action-sampling cameras, and tell a mini story.

The Oktomat's eight lenses are arranged in a 4 × 2 grid, and its shutters are set off in a clockwise sequence starting with the top right shutter. The entire sequence takes 2.5 seconds—a good amount of time to capture some action. The viewfinder is not very user-friendly: you have to flip up two plastic view windows on top of the camera, line them up, and hope that what you are pointing at will be in the picture. As with most action-sampling cameras, I find it is easier to just point in the general direction of my subject and hope for the best!

A nice feature of the Oktomat is that it has a winder lever of the type you find on SLRs from the days before motorized wind-ons. With some plastic cameras it can feel as though you are forcing the film as you wind it on, and it can be difficult to know whether the film is fully advanced. With the Oktomat you simply pull the lever once and you know you're ready for the next picture with no fear of tearing the film. This camera clearly has a lot of internal mechanics and when you set it off, it makes a very distinctive "whirrrrrrrrrzzzzzzzzzclick" sound.

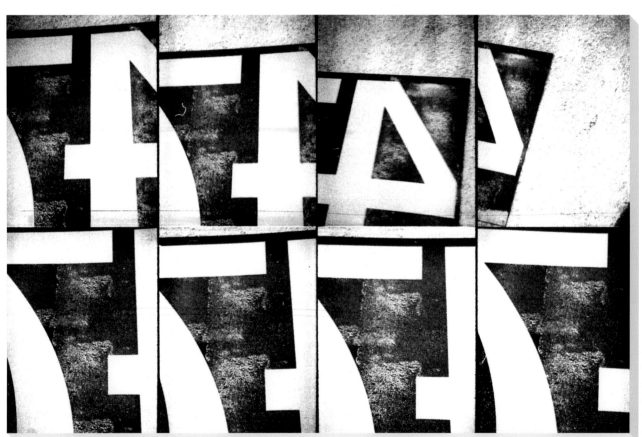

Mantas Pelakauskas

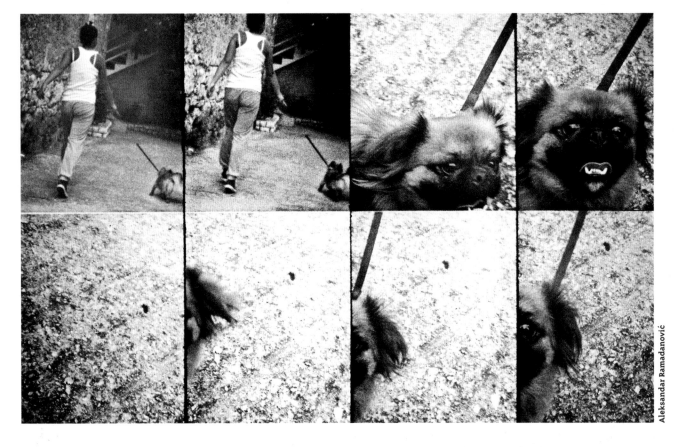

Aleksandar Ramadanović

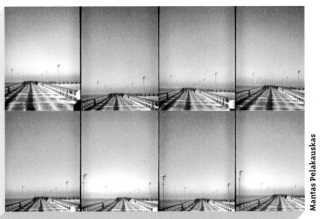

Mantas Pelakauskas

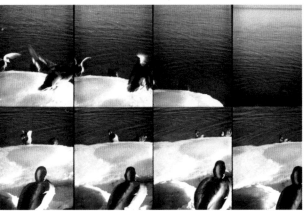

Mantas Pelakauskas

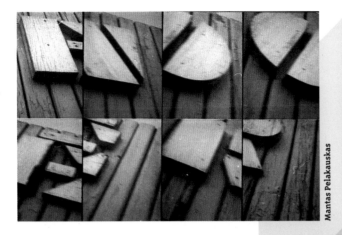

Mantas Pelakauskas

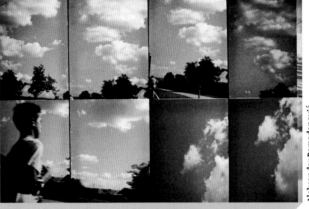

Aleksandar Ramadanović

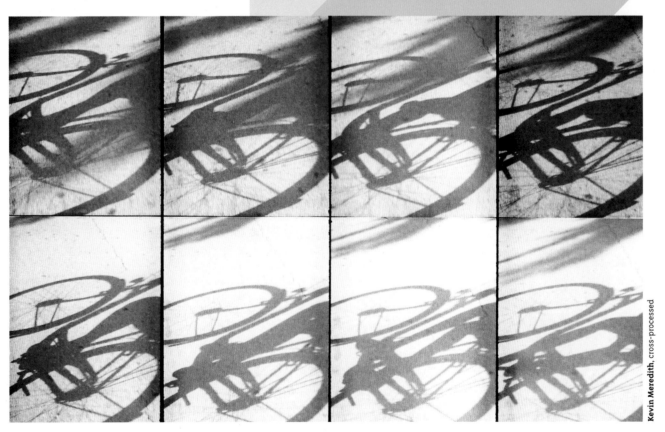

Kevin Meredith, cross-processed

LENSBABY COMPOSER

MEDIUM: —

ISO RANGE: —

LENS: 50mm

FOCUS: 45cm (1½ft) to infinity

FLASH: —

APERTURE: f/2 (with no aperture ring); f/2.8, f/4, f/5.6, f/8, f/11, f/16, or f/22 (with replacement discs)

SHUTTER SPEED: —

SIMILAR CAMERAS: —

VARIANT MODELS: Lensbaby Muse / Lensbaby Control Freak

Pinpoint areas of focus, with blurring in both the foreground and background identify images taken with a Lensbaby.

The Composer is a lens rather than a camera. It is available in mounts for Canon EF (EOS), Nikon F, Sony Alpha A, Minolta Maxxum, Pentax K, Samsung GX, Olympus E1, and Panasonic Lumix DMC cameras. Once the Composer is on a DSLR, it takes away a lot of your control: gone is the autofocus and gone is the aperture control, at least to some extent. You can still change the aperture, but only by replacing the aperture disc. Seven discs give you apertures ranging from f/2.8 to f/22, and if you have no aperture ring at all you get f/2.

As you look through the viewfinder and tilt the lens, you will see the plane of the depth of field change. It takes a little bit of practice, but, once mastered, this makes it really easy to highlight one subject in a busy scene and blur out the rest. You can angle the Lensbaby Composer up or down, which allows you to control the depth of field in your images in new and interesting ways. This type of control, known as tilt-shift photography, can often make your images look like photos of set-up miniature-toy scenes.

There are two other models of Lensbaby: the cheaper Muse, which is available in a plastic or glass version, and the more expensive Control Freak, which, as the name suggests, allows you more precise control over the tilt of the lens. The only alternative to a Lensbaby is a professional tilt-shift lens, which has a correspondingly "professional" price tag.

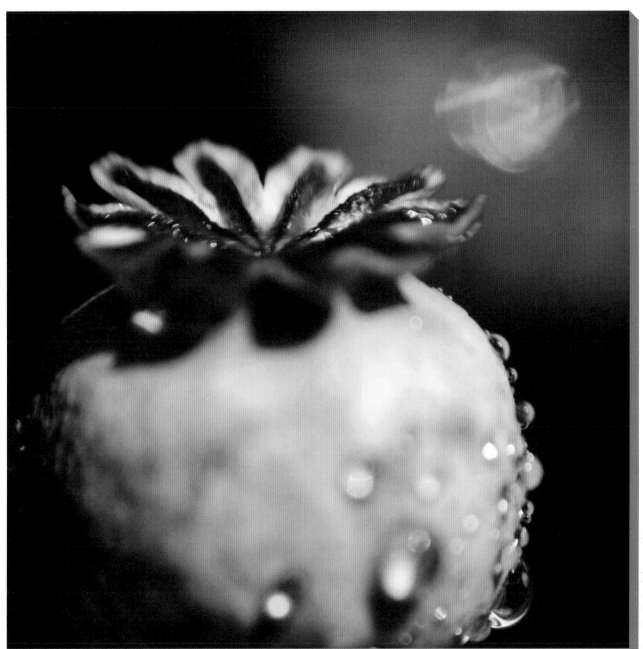

Jason Swain, Lensbaby 2.0 with Macro

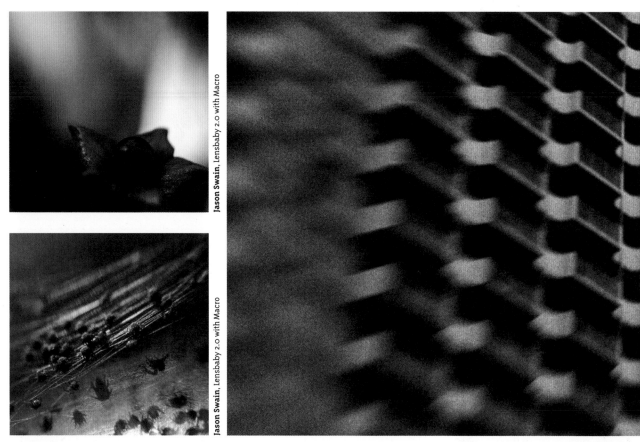

Jason Swain, Lensbaby 2.0 with Macro

Jason Swain, Lensbaby 2.0 with Macro

Kevin Meredith

Jason Swain, Lensbaby 2.0 with Macro

Kevin Meredith

Jason Swain, Lensbaby 2.0 with Macro

Kevin Meredith

Kevin Meredith

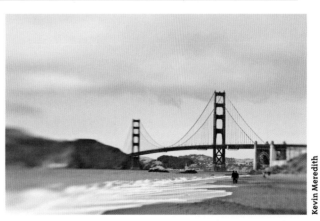

Kevin Meredith

HOLE-ON EX

MEDIUM: 35mm film

ISO: 400

LENS: pinhole, 32mm

FOCUS: 0mm (0in) to infinity

FLASH: —

APERTURE: not specified

SHUTTER SPEED: manual

SIMILAR CAMERAS: Diana F+ (p 42) / Diana Multi Pinhole Operator (p 110) / Science Museum Pinhole Camera / P-Sharan STD-35

VARIANT MODELS: —

Images taken with a Hole-On Ex appear very lo-fi, with light leaks and a gauze-like effect both typical.

The Hole-On Ex comes flat-packed in a package the same size as a 12in record and using it couldn't be simpler.

Pinhole cameras are cameras in their most basic form. They are often home-made, using metal from such things as drinks cans. The Hole-On Ex takes about two hours to assemble and all you need is water-based glue, a ruler, and a pencil, which makes it ideal for children. The trickiest part of making your own pinhole camera is creating the tiny hole for the lens, and this is what makes or breaks the camera. It also affects how long you need for your exposures, so you have to be precise. Fortunately, the Hole-On Ex comes with a ready-made pinhole so all you have to worry about is sticking the cardboard pieces together.

To use the camera all you need to do is make sure it's on a sturdy surface, open the shutter, and then close it. It even comes with an exposure guide that tells you how long to keep the shutter open for under different conditions.

A lot of pinhole cameras use photographic paper or 120 roll film. This means you have to reload them more regularly than most cameras, which is not a good thing, as pinhole photography can be quite experimental. Unusually, the Hole-On Ex takes 35mm film and gives you 36 shots from a 36-exposure roll. There are many pinhole cameras on the market, but the Hole-On Ex is the most widely available; it can be found in museum and design shops around the world and is also sold through Amazon.

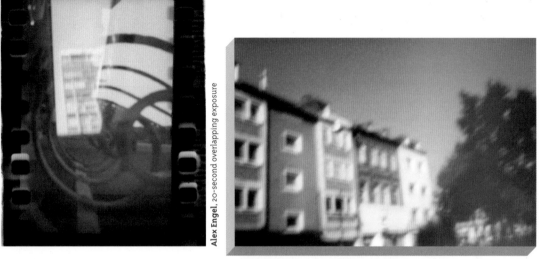

Alex Engel, 20-second overlapping exposure

Gregor Löcher

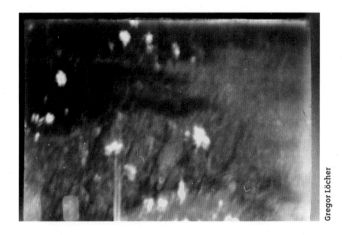

Gregor Löcher

Kevin Meredith, Science Museum Pinhole Camera

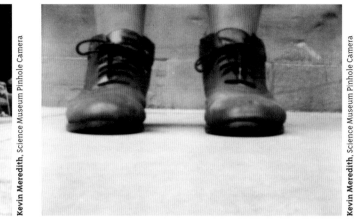

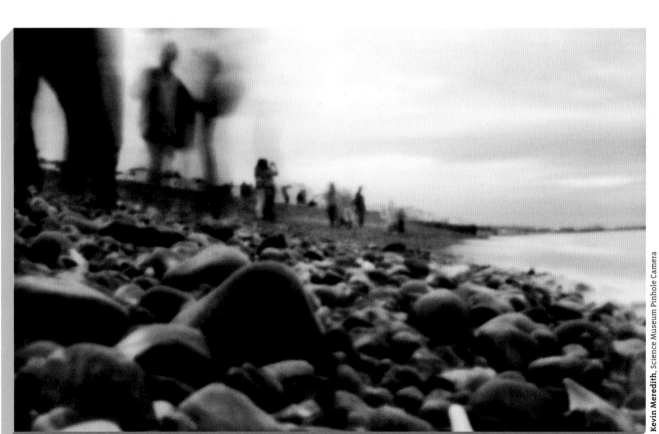

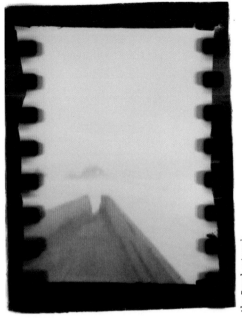

Kevin Meredith, Science Museum Pinhole Camera

Alex Engel, cut mask

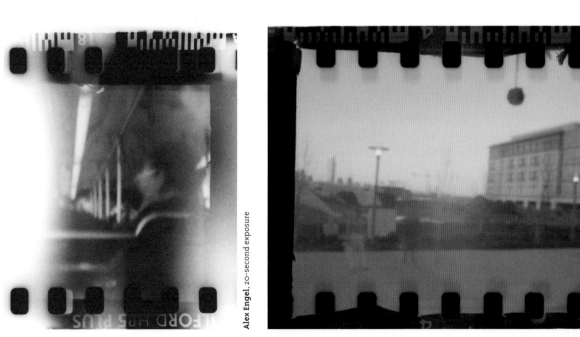

Alex Engel, 20-second exposure

Alex Engel, cut mask

REUSABLE UNDERWATER CAMERA

MEDIUM: 35mm film

ISO RANGE: All ratings available

LENS: fixed, 28mm

FOCUS: fixed, not specified

FLASH: —

APERTURE: fixed, not specified

SHUTTER SPEED: fixed, not specified

SIMILAR CAMERAS: Lomo Frogeye

VARIANT MODELS: —

Water droplets on the lens give many of the Underwater Camera's images a dreamlike blurring.

The Reusable Underwater Camera (RUC) may not have the most exciting name, but it does tell you exactly what it is—an incredibly cheap, no-frills waterproof camera.

Unlike some waterproof cameras, this one has two skins: the camera itself and a housing, which is the waterproof part. This housing also protects the camera from shocks, which makes it a great option if you like rough activities. It can only go to a depth of 8m (26¼ft), but this is fine for most under- and on-the-water usage.

Because the RUC has a fixed shutter speed and aperture, it is best suited to outdoor photography. The camera floats in water, which is very handy because, unless you are in really rough seas, this makes it difficult to lose. Another handy feature is its flip-up viewfinder. It does have an optical viewfinder, but the flip-up option is much easier to use—looking through a tiny hole underwater, with goggles on, is a little tricky.

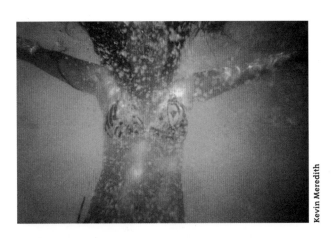

Kevin Meredith

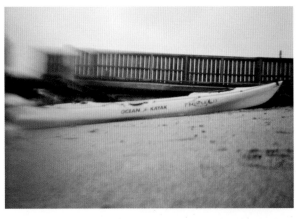

Kevin Meredith

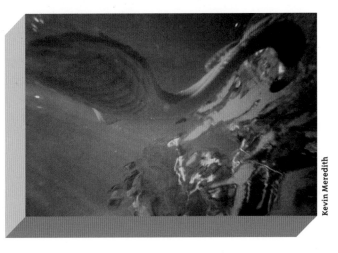

Kevin Meredith

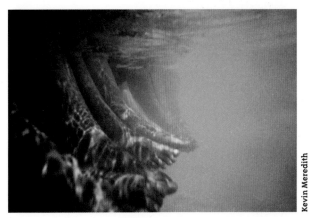

Kevin Meredith

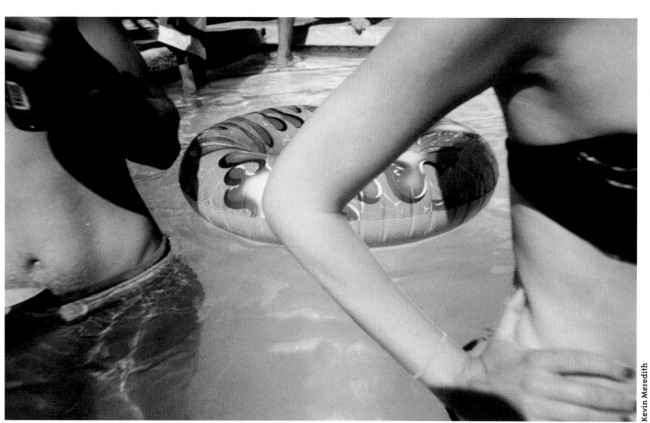

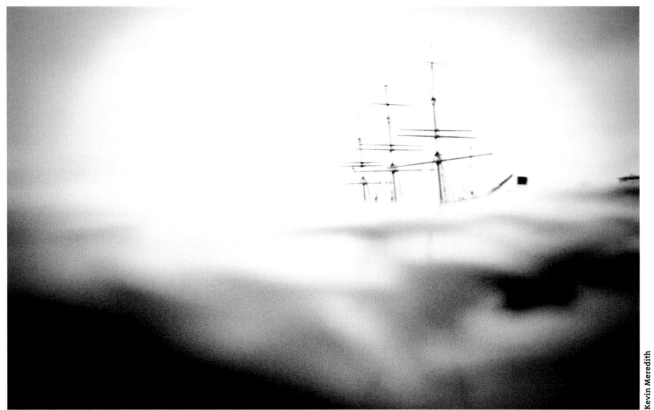

Kevin Meredith

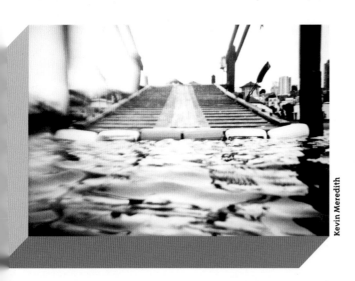

Kevin Meredith

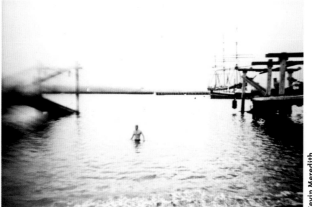

Kevin Meredith

IKIMONO 110

MEDIUM: 110 film

ISO RANGE: 200 or 400

LENS: 13.5mm

FOCUS: 1m (3¼ft) to infinity

FLASH: —

APERTURE: f/11

SHUTTER SPEED: 1/100 sec

SIMILAR CAMERAS: Demekin Fisheye 110 / Holga Micro-110

VARIANT MODELS: Ikimono Flash Buchi

The Ikimono 110 is known for small images with a distinctive grainy appearance.

This is the ultimate in inconspicuous cameras. It is so small—it comes attached to a keyring—people find it hard to take seriously when you use it. As you can guess from the name, this camera uses 110 film. There are loads of cheap plastic 110 cameras available. For the most part they are all pretty similar in that they generally have a set shutter speed and aperture, but the Ikimono is the easiest to get hold of and, when not loaded with film, it is actually smaller than the film cartridge it uses. Because 110 film comes in a cartridge, you can't ruin it by opening the back of the camera as you can with 35mm and 120 roll film, making it almost idiotproof. Obviously, with 110 film the negatives are small (13–17mm), with a surface area of around only 25% that of 35mm film. This means that images taken on the Ikimono can be quite grainy when blown up, which can give them a distinctive feel. The one drawback is that, depending on where you live, it can be tricky to find somewhere to develop the film as not all labs can deal with it in this digital age.

Like a lot of toy cameras, the Ikimono has no exposure control, so it is best suited to bright, sunny days. It takes no room in your bag or pocket so you can keep it on you at all times and whip it out when the sun starts to shine.

A defining feature of the Ikimono 110 is its decorative illustrations of animal characters (*Ikimono* in Japanese), including a cat, bee, panda, and rabbit. With various color/animal combinations available, if you like to collect things, this is the camera for you.

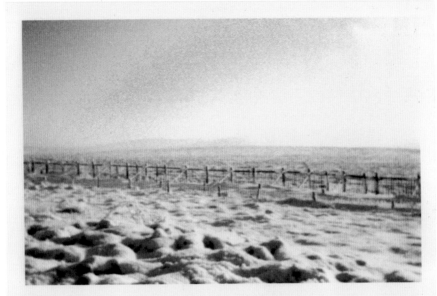

Richard Ingram

Richard Ingram

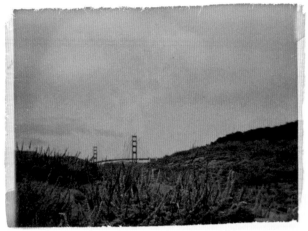

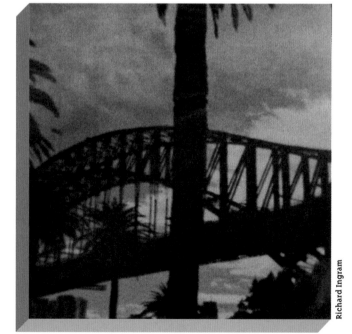

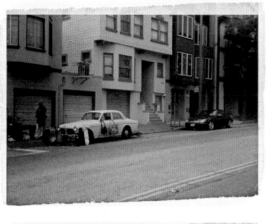

Kevin Meredith

Richard Ingram

Kevin Meredith

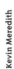

Kevin Meredith

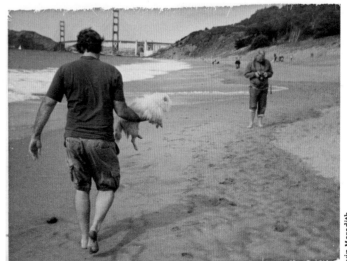

Kevin Meredith

LOMO LC-A INSTANT BACK

MEDIUM: Fuji Instax film

ISO RANGE: 800

LENS: —

FOCUS: —

FLASH: —

APERTURE: —

SHUTTER SPEED: —

SIMILAR CAMERAS: —

VARIANT MODELS: Diana Instant Back

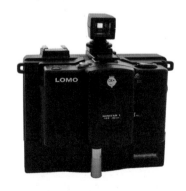

The Instant Back's soft-edged black frame gives its images an exaggerated vignetting effect.

By combining the LC-A+'s multiple-exposure switch and night-shooting capabilities with an instant film, the Lomo LC-A Instant Back allows you to really go to town with your creativity and achieve effects that aren't possible with Instax cameras. An accessory rather than a camera, the LC-A Instant Back converts the Lomo LC-A+ to shoot on Fuji Instax film. The one downside is that it adds quite a bit of bulk to the camera, making it over twice its original size. Once you have converted an LC-A it is very simple to swap between Fuji Instax and 35mm film, although, if you are shooting on Instax film, you have to finish off the pack you have loaded before you can revert to the regular 35mm back, and vice versa. It is possible to use the Instant Back with the first-generation Lomo LC-A, but this makes reloading the shutter a little tricky.

Because of the way the LC-A Instant Back has been designed, the image doesn't fill the entire frame of the Instax film. Instead your images are framed with a soft-edged black border, which accentuates the analog feel of the images—this is Lomo vignetting in overdrive!

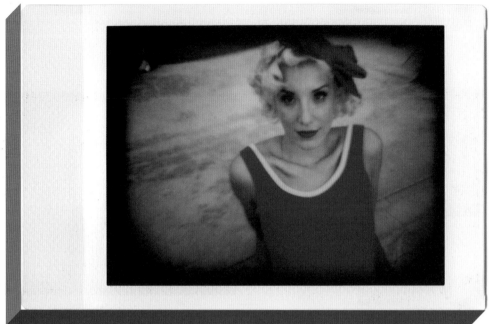

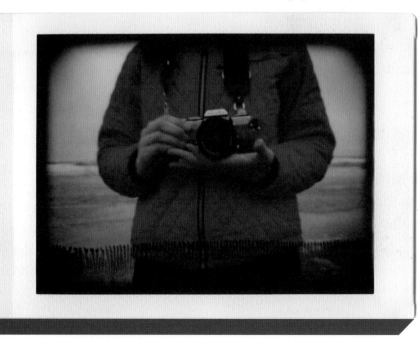

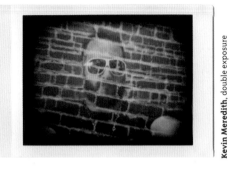

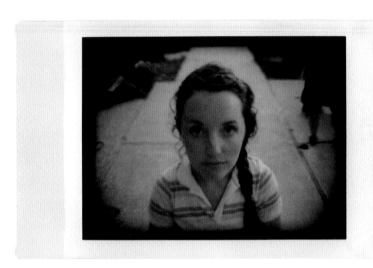

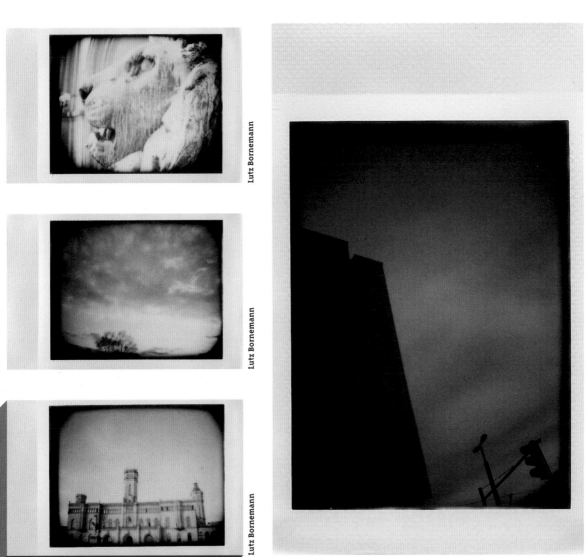

Lutz Bornemann

Lutz Bornemann

Lutz Bornemann

Lutz Bornemann

ROBOT 3

Blurring and heavy grain are typical of photos taken on a Robot 3, but it is the asymmetric arrangement and curved frames of its images that set them apart.

MEDIUM: 35mm film

ISO RANGE: All ratings available

LENSES: three, fixed, plastic, 28mm

FOCUS: 1m (3¼ft) to infinity

FLASH: —

APERTURE: f/8

SHUTTER SPEED: fixed, 1/100 sec

SIMILAR CAMERAS: ActionSampler Clear (p 14)

VARIANT MODELS: Twin Star / Action 4

The Robot 3, often referred to as the Disderi Robot 3, is one of the more funky-looking multi-lens cameras: its three lenses make a friendly robot face. It is also one of the cheapest action-sampling cameras available, which makes it ideal for someone who wants to have a go with an action sampler but doesn't want to splash out on a more expensive model.

The Robot 3 takes three exposures on one negative in a sequence lasting 1/5 sec. The bottom lens fires first and the top two follow, firing left, then right. The lens set-up suggests that the wider image sits along the bottom but as the lens flips the images, the wide image sits above the two smaller ones. The curved frame dividers give the impression that you are observing a scene from a robot's point of view.

Kevin Meredith, cross-processed

Kevin Meredith, cross-processed

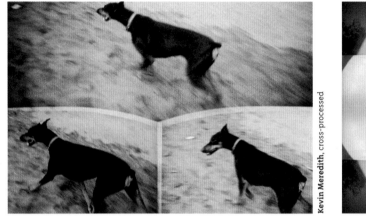

Kevin Meredith, cross-processed

Brendan Murphy, montage of four images

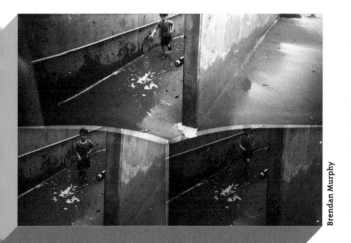

Brendan Murphy

Kevin Meredith

GOPRO WIDE HERO

MEDIUM: digital, SD cards

ISO RANGE: not specified

LENS: wide-angle, with 170° viewing

FOCUS: 10cm (4in) to infinity

FLASH: —

APERTURE: fixed, f/2.8

SHUTTER SPEED: —

SIMILAR CAMERAS: —

VARIANT MODELS: GoPro HERO, GoPro HD HERO

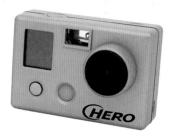

Images taken with the GoPro Wide HERO have an ultra-wide field of view, giving them an interesting sense of distortion.

The GoPro Wide HERO is a go anywhere, do anything camera. No matter what you do in your leisure time, this little camera can accompany you. It is a particularly versatile camera thanks to its range of accessories. These allow you to attach it to anything sporty, whether that be your wrist, bike, surfboard, helmet ... and it is built for action. When you are in the thick of it, it can be hard to trigger and expose shots, but this is not a problem with the HERO because you can set it to take a picture every 2 or 5 seconds leaving you free to carry on with what you're doing. If you set it to take a shot every 2 seconds, you will have enough room on a 2GB memory card to shoot for just over an hour. It's a bit hit-and-miss, but over time you can get some great shots. This timer feature also means that the camera doubles as a great tool for capturing time-lapses, and as well as shooting stills, the GoPro Wide HERO can capture video. If you're a real movie buff, you can get a GoPro HD HERO and shoot video in full HD.

You can get waterproof housings for many digital cameras, but they tend to cost as much as the camera again. The Wide HERO comes with a water-proof housing and, being only 5.3cm (2in) wide, is unobtrusive and light. I shoot in water quite a lot (with big, heavy cameras) and can say from experience that it's great having something that weighs next to nothing compared with other waterproof cameras.

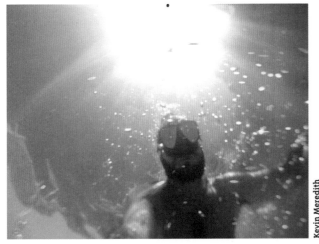

Kevin Meredith

Kevin Meredith

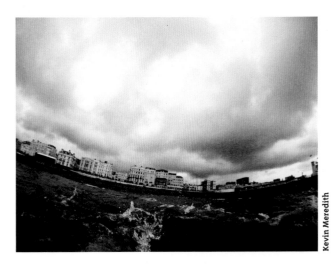

Kevin Meredith

Kevin Meredith

KALIMAR ACTION SHOT 16

Precise spacing and excellent motion freeze set Action Shot 16 images apart from those of other action-sampling cameras.

- -

The Kalimar Action Shot 16 can take a series of photos in rapid succession or with each lens firing in isolation, which allows you either to sample action or create a collage.

Action-sampling cameras have more than one lens, which means they can take a set of photos over a very short space of time. With its 16 lenses, the Action Shot 16 blows other action-sampling cameras out of the water—the more usual numbers are four and eight. It is also one of only two action-sampling cameras in which the shutters are set off electronically rather than mechanically, which allows you to change the timings for each shutter. (The other is the Aryca [p 96].) It was developed as a tool for golfers,

allowing them to photograph their swing and analyze it step-by-step. These golfing roots can be seen in its design—the shutter button is big, white, and dimpled like a golf ball. Unfortunately, the Kalimar Action Shot 16 is no longer made, but they do pop up on eBay now and then.

The lenses are arranged in two rows of eight, and each set of 16 shots uses two negatives. This means you get 18 sets of exposures from a 36-exposure film. There are three different speed modes: exposures can be taken over 1 second or 2 seconds, but the shooting mode that makes this camera unique is its single-shot mode. Using this enables you to control when the shutters are fired manually. This means you can get really creative.

MEDIUM: 35mm film

ISO RANGE: All ratings available

LENS: not specified

FOCUS: fixed, 1m (3¼ft) to infinity

FLASH: —

APERTURE: fixed, not specified

SHUTTER SPEED: not specified

SIMILAR CAMERAS: ActionSampler Flash (p 74) / Aryca (p 96) / Oktomat (p 114)

VARIANT MODELS: —

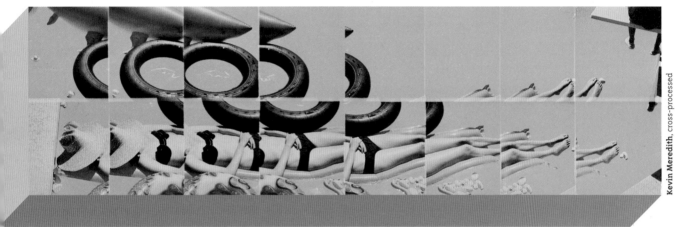

Kevin Meredith, cross-processed

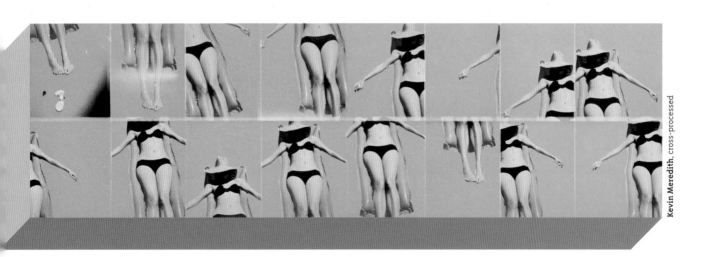

Kevin Meredith, cross-processed

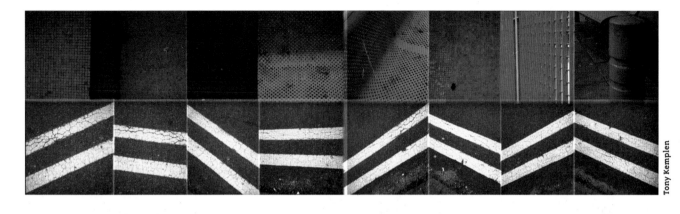

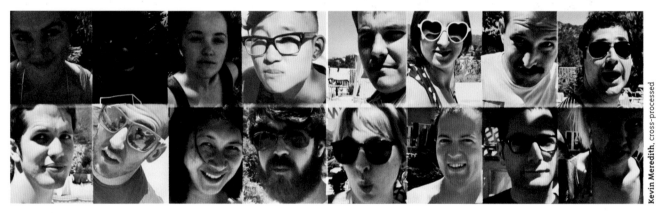

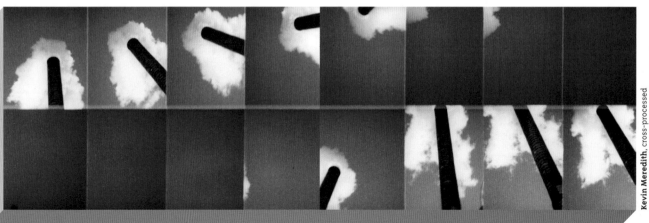

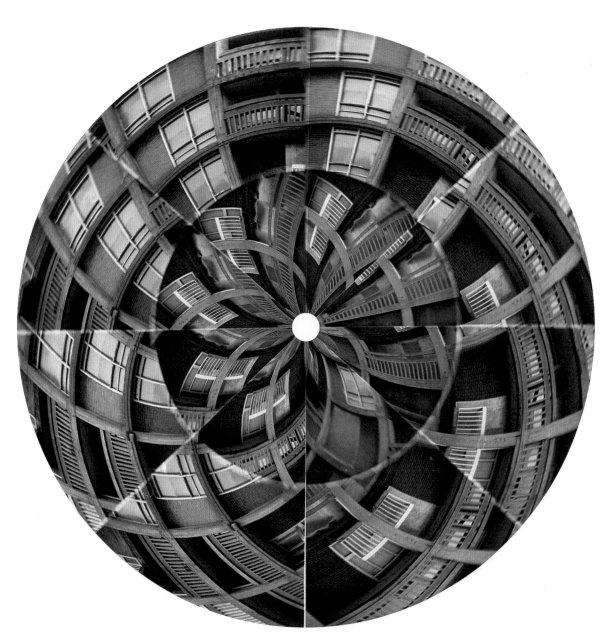

Tony Kemplen, Polar Coordinates filter applied in post-processing

HOLGA 135BC

MEDIUM: 35mm film

ISO RANGE: All ratings available

LENS: fixed, plastic, 47mm

FOCUS: 1m (3¼ft), 1.5m (5ft), 3m (10ft), or infinity

FLASH: hot shoe to take flash

APERTURE: f/8 or f/11

SHUTTER SPEED: 1/125 sec or B (bulb)

SIMILAR CAMERAS: Diana Mini (p 70)

VARIANT MODELS: Holga 135 / Holga 135 PC

The Holga 135BC is known for its very soft, grainy images and light vignetting.

As the Diana has a smaller sibling—the Diana Mini—so the Holga has the Holga 135BC. This takes 35mm film as opposed to the 120 film that the regular Holga takes, which makes it much cheaper to "run" in terms of film and processing costs.

Unfortunately, the Holga 135BC does not have a built-in flash, but it does have a hot shoe so you can use an external flash with it. Because of the fixed shutter speed it is best suited to bright, sunny days, but if you are feeling adventurous you can use the bulb setting to manually open and close the shutter for night shots.

The Holga 135BC makes shooting multiple exposures a breeze. To expose a frame several times all you have to do is press the shutter button repeatedly without advancing the film. Because the lens on the Holga is not the sharpest in the world, the images it produces can be very soft.

Just because the Holga 135BC is a 35mm camera, don't be fooled into thinking it's a compact—it's as wide as the original Holga, just a little shorter—so if you're looking for a carry-around camera, this is not the one. However, despite its size, it is extremely light.

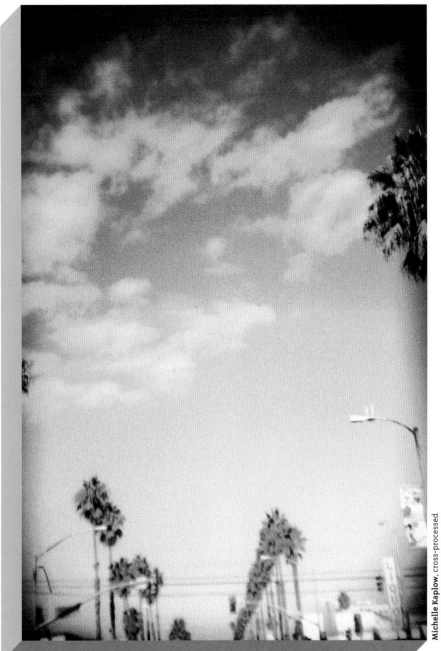

Michelle Kaplow, cross-processed

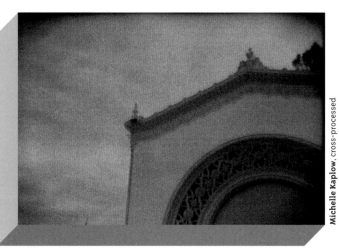

Michelle Kaplow, cross-processed

Kevin Meredith, cross-processed

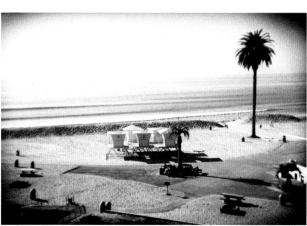

Michelle Kaplow, cross-processed

Michelle Kaplow, cross-processed

Michelle Kaplow, cross-processed

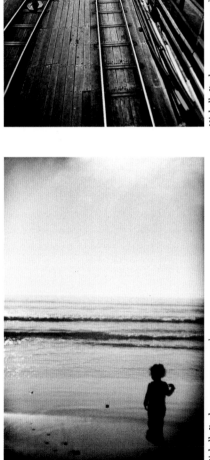

Michelle Kaplow, cross-processed

Michelle Kaplow, cross-processed

LEGO DIGITAL CAMERA

MEDIUM: digital, built-in

ISO RANGE: not specified

LENS: not specified

FOCUS: fixed, 30cm (1ft) to infinity

FLASH: built-in, auto with on/off options

APERTURE: not specified

SHUTTER SPEED: not specified

SIMILAR CAMERAS: Fisher-Price Kid-Tough (p 94)

VARIANT MODELS: —

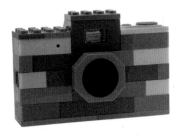

With the LEGO digital camera you come to expect the unexpected in terms of color.

Operating this camera is simple. It is literally a matter of pressing a few buttons: an on/off, a shutter release, a flash button for toggling the flash modes, and three others for viewing and deleting images. The LEGO digital camera looks as though it is made of LEGO bricks and you can, if you so choose, attach your own bricks to the top and bottom of the camera. You can't use the camera with a tripod, but this is not too much of a problem as you can build your own base from LEGO if you need a steady surface. The built-in flash works quite well. If you get too close to your subject, details bleach out, but this is easily fixed by turning the auto flash off.

The LEGO performs quite well in low light without flash. Because of the way its white balance works, you can get some really interesting and unexpected color results under different lighting conditions.

The LEGO doesn't have a memory slot, so you have to make do with the built-in memory—30MB—which gives you enough for 80 shots. The only way to get images off the camera is via a USB cable, and that is also the way to charge the built-in battery. This means that whenever you charge the battery you have to plug the camera into a computer—there is no wall socket option.

Kevin Meredith

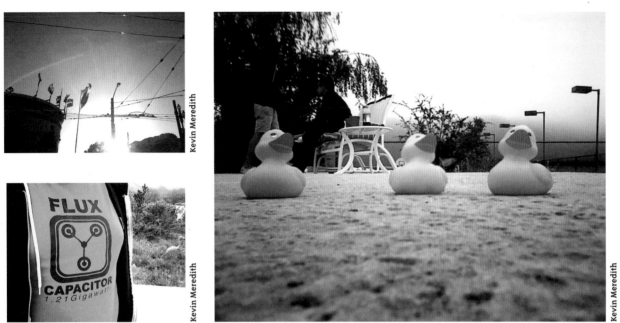

Kevin Meredith

Kevin Meredith

Kevin Meredith

Kevin Meredith

Kevin Meredith

Kevin Meredith

Kevin Meredith

Kevin Meredith

POP-TARTS CAMERA

MEDIUM: 35mm film

ISO RANGE: 400

LENS: fixed, plastic, 35mm

FOCUS: 1m (3¼ft) to infinity

FLASH: —

APERTURE: not specified

SHUTTER SPEED: fixed, 1/125 sec

SIMILAR CAMERAS: Vivitar Ultra Wide & Slim (p 86) / White Slim Angel / Black Slim Devil / Eximus Wide & Slim

VARIANT MODELS: Tony the Tiger camera

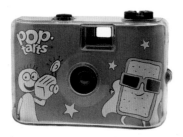

A great little camera for candid portraits and lens-flare effects.

- -

The Pop-Tarts camera was a free gift from Pop-Tarts in the USA, in 2007. It comes loaded with a 12-exposure film, but it's best to throw that away: it makes no economic sense to process a 12-exposure film and, depending on how the camera has been stored, the film might have gone bad. To change the film you need a screwdriver. The Pop-Tarts camera is made for kids and this feature prevents little hands from accidentally opening the back of the camera and exposing the film.

What you see in the viewfinder is pretty close to what you get in your final image. While this becomes less accurate the closer you get to your subject, it doesn't really matter, as anything closer than 1m (3¼ft) from the camera will be out of focus.

As with a lot of cameras that have cheap plastic lenses, you can get some interesting effects when you point it toward the sun or another bright light source. You start to get lens-flare effects that include little rainbows—something you tend not to get with glass lenses. It's good for candid portraits: people won't take you seriously when you pull out a Pop-Tarts-branded camera, which helps you get a more natural shot. However, it is only good for daytime use, as it does not include a flash.

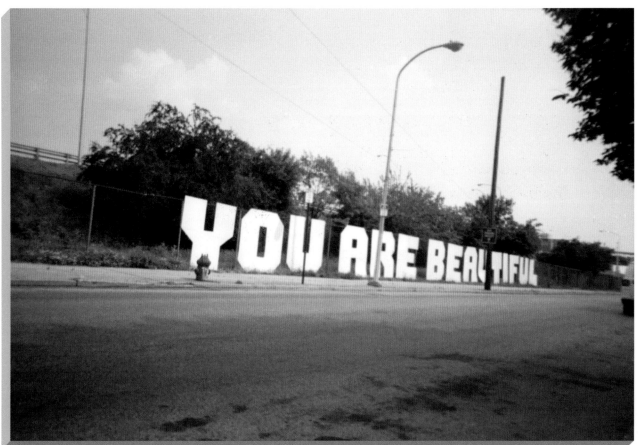

Eric Petersen

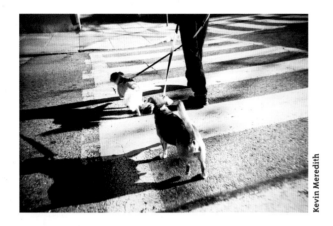

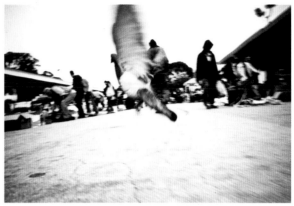

Kevin Meredith

Eric Petersen

Kevin Meredith

ANSCO PIX PANORAMA FLASH

MEDIUM: 35mm film

ISO RANGE: 400

LENS: fixed, 28mm

FOCUS: 1m (3¼ft) to infinity

FLASH: built-in

APERTURE: fixed, f/11

SHUTTER SPEED: fixed, 1/125 sec

SIMILAR CAMERAS: Spinner 360° (p 34) / Ultronic Panoramic (p 54) / Horizon

VARIANT MODELS: Ansco PIX Panorama

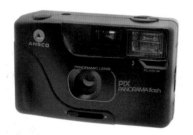

The Ansco PIX Panorama Flash gives a movielike aspect to images and captures great distant detail.

Unlike higher-end panoramic cameras, the Ansco PIX Panorama Flash (APPF) doesn't expose more than one negative; it simply exposes a thin strip across the middle of the frame. This gives its images the appearance of film as the aspect ratio it creates is close to that of a cinema screen. Because the APPF doesn't use the whole height of a 35mm negative, there will be some loss of quality when you blow up your images. The APPF is an interesting camera to use—it makes you think about your composition differently because the frame is so wide. When you get prints or scans of images shot on an APPF back from the lab, they usually have a black bar across the top and bottom. All you have to do is decide whether you want to keep the black bars or crop them out. The wide frame is also handy when you are taking pictures of large groups of people as it keeps the focus on the people rather than on what is around them.

The APPF's viewfinder is pretty spot-on. With some cameras what you see through the viewfinder can be quite different from what you get in the final picture, but with this camera, everything I remember composing in the viewfinder has come out on my final shots. Another handy feature is the flash, which is good for a bit of fill flash with pictures taken in the shade during the day, and it also means you can take the APPF out at night.

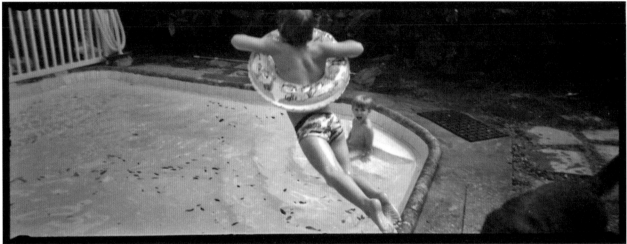

Melisa Taylor, Ansco PIX Panorama

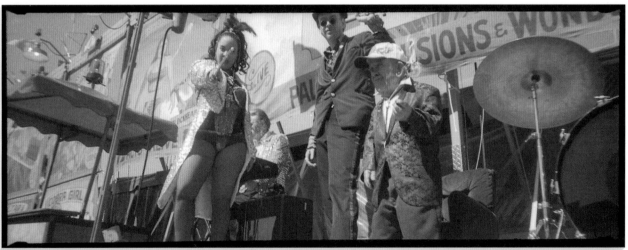

Melisa Taylor, Ansco PIX Panorama

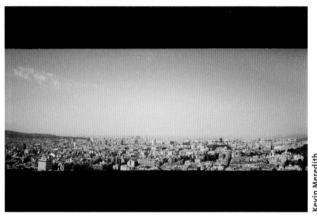

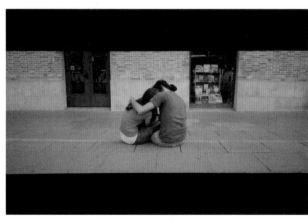

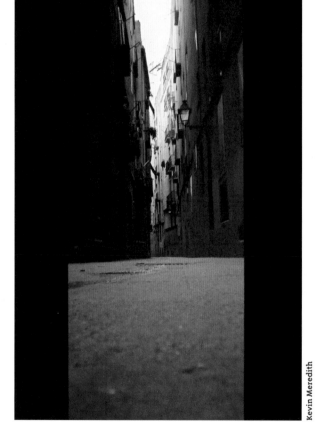

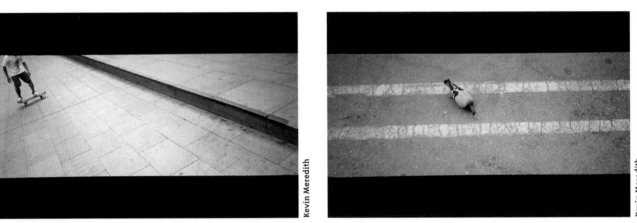

Kevin Meredith

Kevin Meredith

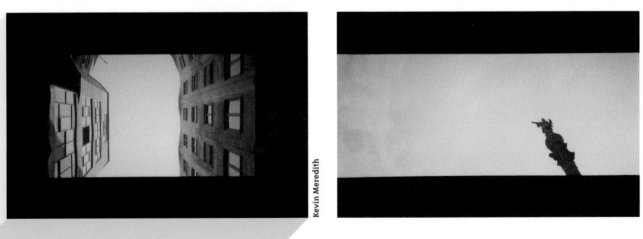

Kevin Meredith

Kevin Meredith

FILM FORMATS & PROCESSING

FILM FORMATS

Over the course of photography's history, hundreds of film formats have come and gone, some fading into obscurity faster than others. Only a handful have remained in use. The film cameras in this book use four types of film: 35mm, 120 roll, 110, and Fuji Instax Mini.

35mm (135) FILM
FRAME SIZE: 36 × 24mm
EXPOSURES: 12, 24, or 36

The most readily available film format is 35mm, also known as 135 film, as "135" is the number that Kodak assigned to this format. The APS (Advanced Photo System) format was introduced in the 1990s as a competitor to 35mm, but with the digital age of photography just around the corner, it failed to establish the foothold that 35mm film has.

Film comes loaded in canisters, in 12-, 24-, or 36-exposure rolls. Depending on what camera you use and how you load it, it is possible to squeeze 40 exposures from a 36-exposure film. Most photo labs will charge you the same fee to process a 24- or a 36-exposure film, so using anything less than a 36 is not cost-effective. Because the film is pulled out of the canister as you shoot, it has to be wound back into the canister once you have finished. Some 35mm cameras work in the opposite way; when the camera is first loaded the film is pulled out of the canister, and then wound back in as you shoot.

120 ROLL FILM

FRAME SIZE: 56 × 56mm or 56 × 41.5mm
EXPOSURES: 12 or 16

110 FILM

FRAME SIZE: 13 × 17mm
EXPOSURES: 24

120 roll film is sometimes referred to as medium format because, size-wise, it sits between large film formats and 35mm film. 120 film is associated with professional photography because of the high-quality images it can produce. Some people find it a little tricky—it isn't as user-friendly as 35mm film. 120 roll film comes on a spool; when you load it into a camera you have to attach one end of the film to another spool that the film will wrap around as you shoot. There is no need to rewind as the completed film will be wrapped around this second spool, leaving the spool your film came on ready to load the next film onto.

While 120 film can be shot in a number of formats, the following two are what most 120 toy cameras will let you shoot: a 6 × 6 frame size will give you 56 × 56mm and 12 exposures out of one roll; 6 × 4.5 will give you 56 × 41.5mm and 16 exposures from a roll.

110 roll film is the smallest film format in this book. It is easy to load—all you have to do is clip the film into the camera—but it can be difficult to get it developed and scanned as most labs will only deal with 35mm, APS, and, if you are lucky, 120 film. 110 film comes in a self-contained cartridge and is wound from one spool to the other, which means you don't have to worry about rewinding. Ironically, the cartridge tends to be larger than most of the cameras that take it—the film spools hang out each side of the camera. 110 films are only available as negative film; the production of 110 slide film was ceased in the early 1980s.

FUJI INSTAX MINI FILM

FRAME SIZE: 64 × 46mm
EXPOSURES: 10

Fuji Instax Mini is an instant film that has survived due to its massive popularity in Asia. Fuji is still designing new cameras that take the format. Each pack of Instax Mini contains 10 exposures. There is something special about instant photography; when you shoot an instant image you create a unique work of art. If you shoot on negative film, you can reproduce a picture any number of times. You can scan instant pictures, but there is only ever one original and that makes them seem so much more precious.

IMAGE QUALITY

With image quality, the rule of thumb is that the larger the negative frame, the better the quality of prints and scans obtained. For the cameras covered in this book, that suggests 120 roll film will give you the best results as it is the largest film format, followed by Instax Mini, 35mm, and 110 film. However, there are other factors that can affect image quality, including the sharpness of the lens. A 35mm camera with a better lens than a 120 camera might give you better results. Your choice of film speed will also affect image quality because low-speed films have a finer grain than high-speed films. But sometimes it's best not to get hung up on traditional notions of quality, as a grainy, soft-focus image could be the aesthetic you are looking for. After all, that is what toy-camera photography is all about—embracing imperfections.

PROCESSING

It has become harder and harder to find decent labs to develop and scan film because most people shoot on digital, so the demand for their services has fallen. For the most part, developing film is a standardized process so it is much the same everywhere. However, the particular equipment used and how well it is maintained can affect the quality of the negatives developed as far as dust and scratches are concerned. When it comes to scanning and printing it can be a different matter, as the color and contrast in your pictures is down to how the equipment used is calibrated and to the preferences of the operator on that day.

Film has quite a long shelf life if it is stored correctly and will sometimes work fine even a few years outside of its sell-by date, but once shot you should develop it as soon as possible: over time, an exposed film can start to lose color.

SPECIAL TECHNIQUES

There are a couple of processing techniques you can try if you want to give your pictures extra flair: cross-processing and redscale.

For cross-processing you shoot slide film, but ask the lab to develop it as they would a negative film, or vice versa. A slide film is usually developed in E6 chemicals and a negative film in C41. When a film is processed in the "wrong" chemicals, you get a high-contrast, high-saturation result (and a negative instead of a positive slide, or a slide instead of a negative). But be warned—some films cross-process better than others.

Redscale film is film that has been taken out of its canister and put back in the wrong way around. You may have noticed when you load film that it has one glossy and one matte side; the matte side is what is normally exposed to the light, but with redscale film it is the glossy side. This has the effect of making the images red and yellow. Taking a film out of its canister and reloading it in the dark is tricky. Luckily, you can buy redscale film already prepared.

TOY CAMERA BASICS

For the most part, toy cameras are very easy to use. They should be child's play! Most of the time that is true, but having a little knowledge of photography does help you get the best from your plastic fantastics.

Photographic images are recorded onto film or digital sensors. They need just the right amount of light to record an image. This "amount of light" is referred to as an exposure. The aim of a camera is to get a well-balanced exposure—basically, to avoid an overexposed (too light) or underexposed (too dark) image. Getting a good exposure is down to three things: shutter speed, aperture, and film/sensor speed. Most of the cameras in this book have fixed shutter speeds and apertures. This means they are only really good for shooting in daylight (and that is what they are designed to do), unless they have a flash, in which case you can snap away in low light as long as your subject is within the flash's range.

SHUTTER SPEED

The shutter speed, measured in fractions of a second, controls the amount of time that the film/sensor is exposed to light. Images shot with slower shutter speeds may show motion blur, which can be an undesirable effect. Most toy cameras have shutter speeds just fast enough to avoid motion blur, but if you are moving too much you will get some. Most of the cameras in this book have shutter speeds of around 1/125 sec. If a toy camera allows you any control over shutter speed, it is usually a choice between a standard setting and bulb. When the shutter is in bulb mode, it will stay open for as long as you keep the shutter button held down. This comes in handy for nighttime photos when the camera will need more light for a balanced exposure, but be warned—if you use it during the day, your photos will come out overexposed. With cameras on which you can change the shutter mode to bulb, the bulb setting is usually indicated with B and the normal setting marked as N. Don't make the common mistake of assuming N stands for Night mode!

APERTURE

The aperture, a hole that lies between the lens and the film/sensor, controls the amount of light hitting the film/sensor. It does this through adjustments to its size. The aperture has an effect not only on the exposure, but also on how sharp an image is: the smaller the aperture, the greater the area of image in focus. The downside to this is that the smaller the aperture, the longer the shutter needs to be open. On most toy cameras you can't adjust shutter speed or aperture, but with those that you can, this tends to be really simple. You usually get the choice of two, and sometimes three, aperture settings, most often sunny (the smallest aperture), cloudy (the largest aperture), and if you are lucky partly cloudy (somewhere in between).

FILM SPEED

Film speed is an important consideration when using a toy camera. A fast film is more sensitive to light, so it will collect light "faster" than a slow film. A film's sensitivity is given as an ISO number. The higher the ISO, the more sensitive the film will be to light. An ISO 200 film is twice as sensitive as a 100, and an 800 is twice as sensitive as a 400. As you can't control the exposure setting on most toy cameras, the only way you can have any control over exposure is through your choice of film. ISO 400 is what most people use with a toy camera in daylight, but if you are guaranteed that all your photos will be taken in direct sunlight, with no cloud cover, you can use 100 or 200 film. If you know that you are going to be shooting on a really dull day you can use an 800 film. ISO 800 color film can be grainy and the colors may not look as punchy as what you will get with a low ISO film, but that is better than underexposed shots.

CONTRIBUTORS' DETAILS

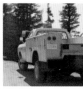

PETTER BÅTSVIK RISHOLM
Norway

CHAWEE BUSAYARAT
www.flickr.com/photos/
chaweemek/
Thailand

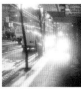

HANNAH DENNIS
aka hesperootoo
www.flickr.com/photos/
48714581@N06/
UK

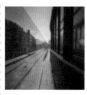

CHRISTOPHER EVANS
www.flickr.com/photos/czarf/
Canada

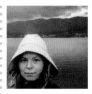

BEN BIRK
www.benbirk.com
www.flickr.com/photos/benbirk/
USA

JAMES BUTLER
aka slimmer_jimmer
www.flickr.com/photos/slimjim/
UK

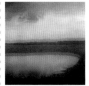

TONY DeFILIPPO
www.flickr.com/photos/
tonydefilippo/
USA

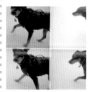

PAULA GIMENO APARICIO
aka cuantofalta
www.flickr.com/photos/
cuantofalta/
Germany

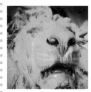

LUTZ BORNEMANN
aka zark_likes_skulls
www.lomography.com/
homes/zark
www.flickr.com/photos/
24135698@N06/
Germany

JOHN CATBAGAN
aka catbagan
jtcatbagan@yahoo.com
www.flickr.com/photos/
jtcatbagan/
USA

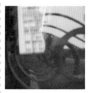

ALEX ENGEL
USA

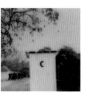

ESSIE P. GRAHAM
www.epgphotography.com
www.lomography.com/homes/
inetstrkid
www.flickr.com/photos/egraham/
USA

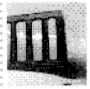

EDD HANNAY
aka Edd!
www.flickr.com/photos/
eddhannay/
UK

RICHARD A. INGRAM
www.richardaingram.co.uk
www.flickr.com/photos/
richardaingram/
UK

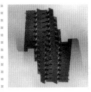

LUKAS KERNER
aka LukeΔJuggernaut
www.flickr.com/
photos/50594680@N07/
Germany

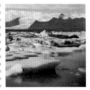

DIANE LEYMAN
notestoafurtherexcuse.
blogspot.com/
Australia

DAVID HAURE
aka fandechi
www.flickr.com/photos/fandechi/
France

MICHELLE KAPLOW
aka The Dalai Lomo
www.thedalailomo.com
USA

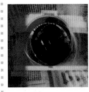

ANDREW KUA
aka ndroo
www.fuzzyeyeballs.com
www.flickr.com/photos/
fuzzyeyeballs/
Singapore

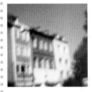

GREGOR LÖCHER
aka batudiste
http://batudiste.com/
www.flickr.com/photos/batudiste/
Germany

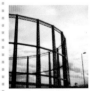

DUNCAN HOLLEY
aka fitzhughfella
www.flickr.com/photos/
duncanholley/
UK

TONY KEMPLEN
aka pho-Tony
www.kemplen.co.uk
www.flickr.com/photos/tony_
kemplen/
UK

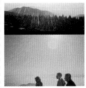

WEI-I LEE
leeweeii@gmail.com
www.flickr.com/photos/leeweeii/
Taiwan

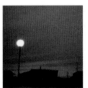

HIROSHI MATSUMURA
aka dragonpeace
www.flickr.com/photos/
dragonpeace/
Japan

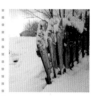

JENNIFER MILLER
aka Ron J. Añejo
www.flickr.com/photos/ronanejo/
Canada

JIM NOWLIN
aka Evil Game Boy
www.flickr.com/photos/
98086715@N00/
USA

MARIO PEREZ
aka molotovito
marioperez1@gmail.com
www.flickr.com/photos/
23219901@N00/
USA

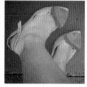

EMILY PORTNOI
www.flickr.com/photos/
emilyportnoi/
UK

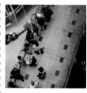

HELEN MILLS
aka Millie_Scarlet
www.scarletdesigns.net
www.flickr.com/photos/millie_
scarlet/
UK

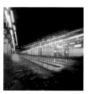

RIE OSHIMA
Japan

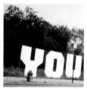

ERIC PETERSEN
aka epmd
www. flickr.com/photos/epmd/
USA

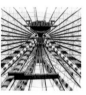

FARZAD QASIM
www.iamjpg.com
Ireland

BRENDAN MURPHY
aka murphyeppoon
www.brenmurphy.com.au
www.flickr.com/photos/
29501884@N04/
Australia

MANTAS PELAKAUSKAS
http: //mantozauras.
wordpress.com
Lithuania

JEFF PHANER
www.flickr.com/photos/jeff_
phaner/
Canada / France

ALEKSANDAR RAMADANOVIĆ
alexei021@gmail.com
Serbia

BRIAN SCHATKO
aka brionline
www.flickr.com/photos/brionline/
USA

YUSUKE T
aka golden.punk.arrow
www.flickr.com/photos/
golden_punk_arrow/
Japan

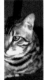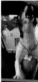

CHEYENNE K. SPRENGER (AGE 8)
CODY D. SPRENGER (AGE 4)
Kerie Campbell (Cheyenne
and Cody's mother)
aka Major Malfunction
www.flickr.com/photos/
31799986@N04/
USA

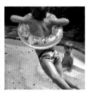

MELISA TAYLOR
melisataylor@mac.com
http://melisataylor.blogspot.com
http://melisataylor.etsy.com
www.flickr.com/melisataylor
USA

JASON SWAIN
aka s0ulsurfing
www.jasonswain.co.uk
www.flickr.com/photos/
s0ulsurfing/
UK

MARTIN THOBURN
aka duiceburger
www.martin-thoburn.com
www.flickr.com/photos/
duiceburger/
USA

ACKNOWLEDGMENTS

Adam Scott and Golfpunkgirl from the Lomography store in London for lending me lots of cameras and for the tips and tricks on their lomographic goodies. Serge Rolland at Zoing Image for cameras and hard-to-find specs on some of the more obscure models. Andy Wilson for lending me some of his plastic fantastics. Edd Hannay for pulling images off my Game Boy camera onto a PC—you made my life a lot easier!

I would like to thank the following people for contributing photos to this book: Petter Båtsvik Risholm, Ben Birk, Lutz Bornemann, Chawee Busayarat, James Butler, John Catbagan, Tony DeFilippo, Hannah Dennis, Alex Engel, Christopher Evans, Paula Gimeno Aparicio, Essie P. Graham, Edd Hannay, David Haure, Duncan Holley, Richard Ingram, Michelle Kaplow, Tony Kemplen, Lukas Kerner, Andrew Kua, Wei-I Lee, Diane Leyman, Gregor Löcher, Hiroshi Matsumura, Jennifer Miller, Helen Mills, Brendan Murphy, Jim Nowlin, Rie Oshima, Mantas Pelakauskas, Mario Perez, Eric Petersen, Jeff Phaner, Emily Portnoi, Farzad Qasim, Aleksandar Ramadanović, Brian Schatko, Cheyenne Sprenger, Cody Sprenger, Jason Swain, Yusuke T, Melisa Taylor, and Martin Thoburn.

Thanks also to the following people who let me shoot them for inclusion in this book: Sara Beer, Matilda May Meredith, Stevey Jelbat, Emma Sandham-King, Andy Wilson, Andy Budd and the Clear Left Crew, Amit Gupta, Fiona Miller, Olivia Wright, Max FitzGerald, Talyor Newman, Bruce Black, Brad Smith, Alexandra Fulton, Laura Brunow Miner, Paul Octavious, Cody Austin, Steph Goralnick, Dan Buster, Nate Bolt, Mona Brooks, Brad Smith, Lis Bolt, Mark Trammel, Jennifer Giese, and Eddy Joaquim.

INDEX